Composition In Portraiture

Sadakichi Hartmann

M 70

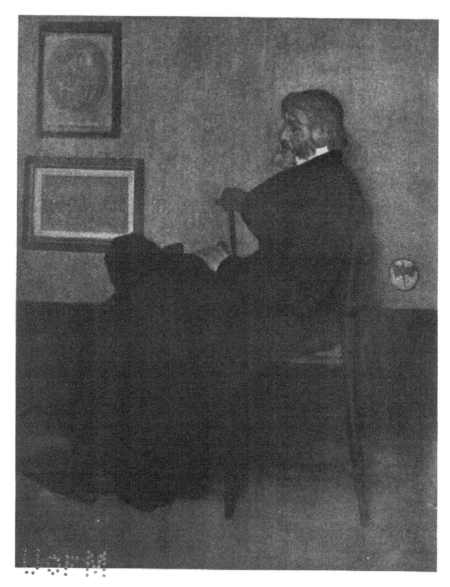

"Carlyle." By Whistler

Illustration to Chapter VII. Sitting positions

COMPOSITION IN PORTRAITURE

BY

SIDNEY ALLAN

(SADAKICHI HARTMANN)

WITH ONE HUNDRED AND THIRTY-SIX HALF-TONE
ILLUSTRATIONS AND NUMEROUS DIAGRAMS

NEW YORK
EDWARD L. WILSON
1909

.

Copyright, 1909, by Edward L. Wilson

DORNAN, PRINTER
PHILADELPHIA

FOREWORD

Sidney Allan, Esq., New York.

My dear Mr. Allan:

What you write on art is always interesting. You have undertaken a difficult subject this time. Although I consider the knowledge of composition largely a matter of experience and natural ability, I must confess that your discussions are the sanest and most practical ones I have ever read on the subject. No doubt every student, engaged in portraiture, will appreciate the arguments you have made in such a simple and straightforward manner.

Cordially yours,

New York, December 7, 1908.

CONTENTS

7

Composition in Portraiture

INTRODUCTION

EON BATTISTA ALBERTA, in 1540, was the first painter known to history who theorized at length in a book about the art principles of portraiture. Since then the discussion has become a continuous one, and every year is sure to add a few volumes to its bibliography.

Portraiture has always existed, at least as early as human hands knew how to draw or cut in stone, and an old legend tells us that the reproduction of the human face was first practised by some Oriental prince, who saw the shadow of his sweetheart's profile on a wall and wished to preserve it. It is doubtful, however, whether any of these earlier attempts on vases, tablets, and temple walls could be called portraiture as we understand it today. The reliefs of Egyptian and Assyrian kings were surely nothing further than the representation of types (of ethnological interest), and not characteristic delineations of individual personalities.

Professional portraiture, in the modern sense, originated in the Middle Ages, and apparently simultaneously in Holland and Italy. All the Italian Old Masters practised portraiture, but they considered it—despite the many masterpieces they produced in this branch of painting—as something secondary, and not conforming

to the highest art ideals. In Holland, however, where art had a more realistic tendency, it was regarded from the very start as one of the noblest pictorial expressions, and reached its highest development with Rubens, van Dyck, Hals, and Rembrandt, during the seventeenth century. At the same time portraiture also attained a rare state of perfection in Spain, with Herrera, Zurbaran, Murillo, and Velasquez as principal exponents.

The portraits of those times have never been excelled. Their range of utility, however, was a limited one. Portraiture had not yet reached the democratic proportions of today. It restricted itself (largely due to the conditions of the time) to men and women of prominence, distinguished for character or rare beauty, and such types as the artist himself thought worthy of delineation. For that reason they generally show good workmanship, but how far they are correct as likenesses is beyond our capacity of judgment. I believe people were formerly more easily satisfied, or perhaps, as nearly all the patronage came from the educated leisure class, actually preferred (it is hard to believe) esthetic and pictorial qualities to those of mere likeness. It was nothing but an esthetic enjoyment for the few who like to see a personality delineated as another personality sees it. The same can really be said of portrait painting as it is practised today by a Sargent, Zorn, Boldini, or Blanche.

Photographic portraiture is an entirely different proposition. It is a record, the record of a person at a

certain age, in a certain mood, in a certain garb, etc., and we do not look for *typical*, but strictly for *characteristic* traits, such as will appeal to the sitter's inner circle of friends, who all have their individual opinions about his or her looks. Of course, we like the portrait to be in good taste, of elegant finish, artistic, and all that, but the large public knows but little of truth of values, division of space, contrast of light and shade, etc. It may appreciate these qualities in a picture, but it has not the power to analyze them.

The photographer is in a double dilemma. First, he has to deal with the ignorance of the public in such matters; and secondly, with the shortcomings of the photographic process. There is no art which affords less opportunity to executive expression than photography. Everything is concentrated upon a few seconds, when, after perhaps half an hour's seeking and experimenting, arranging and re-arranging, he sees before him exactly what he wants to get, and in *that moment alone* he has an advantage over most arts—his medium is swift enough to record his momentary inspiration.

True enough, the finest, most artistic arrangement and pose may be spoiled by improper exposure, etc., but after all, in most cases *a good print proves to be the result of what has happened in the studio previous to pressing the bulb.* Or, in other words, to consider every fluctuation of color, light, and shade; to study lines, values, and space division, and to patiently wait until the scene or object to be depicted reveals itself to its best advantage—in short, to arrange the picture so

well that the negative will be perfect and in need of no, or but slight, manipulation.

The process of posing is half the battle, and I believe the majority of professionals will endorse my statements. As aforesaid, the photographer who strives to be artistic works under an extreme difficulty. No matter how learned in art matters he may be, all he can apply is merely what will come to him during the process of posing. He cannot command numerous sittings, like the portrait painter. In his studio one sitter follows the other. He has hardly any time to get acquainted with them. He has to rely on his momentary judgment. His art knowledge must be second nature with him, or it is of no use at all.

It is from this viewpoint that I intend to approach the problem of composition, which will be the topic of this series of discussions. I am of the opinion that most books on this subject, excellent as they may be, have treated it in too pedantic and pedagogical manner. The theories of these writers are too elaborate, involved, clogged up, as it were, to be of practical use. No man can remember all they say about obliterated verticals and circular attraction, etc., particularly a photographer who cannot gradually construct and improve a composition. Why not talk plain English?

Besides, no painter really argues out these things while he paints. He feels them intuitively. As a painter said to me one day: "We do things and then you critics come and talk about how we have done it, when we hardly know it ourselves." There is a good

deal of truth about this statement, and yet it is equally true that there are some fundamental laws and principles of composition, and that all great painters have mastered it. It matters little how, whether by natural talent, or by gradual acquisition. The best proof of it is the scarcity of good compositions.

To prove how important a part the constructive element played in the creations of the Old Masters, it will be only necessary to mention some masterpiece of art, like Leonardo da Vinci's "Last Supper," Raphael's "Sistine Madonna," or Titian's "Entombment of Christ." How marvellously do all the lines in da Vinci's picture converge to the central figure of Christ; he made the laws of perspective the laws of his composition. Raphael composed in an entirely different manner. He applied the typical geometrical forms of nature with preference, the triangle, the circle, and the ellipse, giving them full sway to reign in supreme beauty and significance over the creations of his brain. Titian proved that an accurate juxtaposition of colors and the relations of their tones can be just as valuable for the making of a perfect picture as perspective and geometry. Michael Angelo regarded architecture and the plastic element of sculpture as the foundation of great paintings, and Rembrandt believed that the massing of light and shade was sufficient to produce a masterpiece. Each of these men excelled in his style of composition, which had become a part of their individuality, and one was as good as the other.

Their elaborate compositions, of course, have nothing

to do with portraiture, something which most writers on composition seem to overlook. They talk, page after page, about some huge composition, with dozens of figures in it, something that never happens in photography, unless it were a college group or one of Herzog's decorative experiments. I merely referred to them to show how much, after all, may hinge on composition.

The idea about composition has somewhat changed in modern times. Composition is no longer considered by painters as absolutely essential. It is even disregarded by the realists and impressionists, or at least subordinated to other qualities. They want to represent life as it is, and claim that there are no cast-iron laws to go by, and that nature cannot be improved upon. True enough, composition cannot be narrowed down to a number of laws which assure success to everyone who slavishly follows them. On the other hand, artists like Chavannes, Manet, and Whistler have proved that the decorative treatment of lines and planes, the striving for absolute realism in the handling of every-day themes, and a low-toned or high-keyed harmony of color are as effective as the elaborate technical resources of the Old Masters. Yet I doubt very much if they are not just as dependent on certain principles of composition as their predecessors, the only difference being that they proceed with less mathematical calculation, work more unconsciously, perhaps—not because they know less; on the contrary, because they know more, or at least have seen more. They have seen

everything that art has ever produced, and their knowledge of composition really embraces the entire history of art, ancient, mediæval, and modern—Oriental as well as Occidental.

All that I shall attempt to do in my treatise is to analyze composition, as far as it is of moment to portrait photography, and to come down to the few fundamental laws which underlie all portrait composition, those which every photographer should know, and I will endeavor to make my statements in as simple and straightforward a manner as possible.

Chapter I will be on the placing of the head, which is largely a matter of space arrangement. I will then go into details, and discuss successively the full-face view, the profile, and three-quarter view, and their variations. I shall try and reduce the latter to their very minimum. For instance, in the profile view only three positions of the head are possible. It is either looking straight ahead, upward, or downward. I shall discuss the esthetic and pictorial significance of each of these, and thereby endeavor to exhaust all the artistic possibilities of the profile view.

Two other chapters will treat the leading positions of the body, which must be either standing, seated, or reclining. In the remainder of the series I shall take up group composition, treatment of the hands, and a general survey of line, tone, values, and chiaroscuro.

I shall mention the Old Masters as rarely as possible, as nothing can be gained by imitating them. Of course, we can learn from them, but rather from

the spirit with which their work is imbued than from any actual facts they represent. Times have changed, the costume and "environment" of our period are less picturesque, our ways of living and our methods of lighting interiors are totally different to those of even a hundred years ago, and we have different ideas and ideals of life.

What we admire in the Old Masters, I fear, is largely their tonal quality. Tone, true enough, is an important adjunct to portraiture; no print should be without it. But it is, after all, merely *one* of the elements that enters into the making of a picture, not the whole thing, as some of the faddists want to make us believe. Tone in old pictures is frequently merely the appearance of old age, an artificial product produced by dirt and dampness, the chemical action of light, and the gradual change of color, oil, and varnish. For that reason I shall use in my series of articles few Old Masters as illustrations, but largely reproductions of portraits by modern painters, and occasionally also such photographic portraits as may be specially applicable to my arguments.

CHAPTER I

THE PLACING OF THE HEAD

M to U

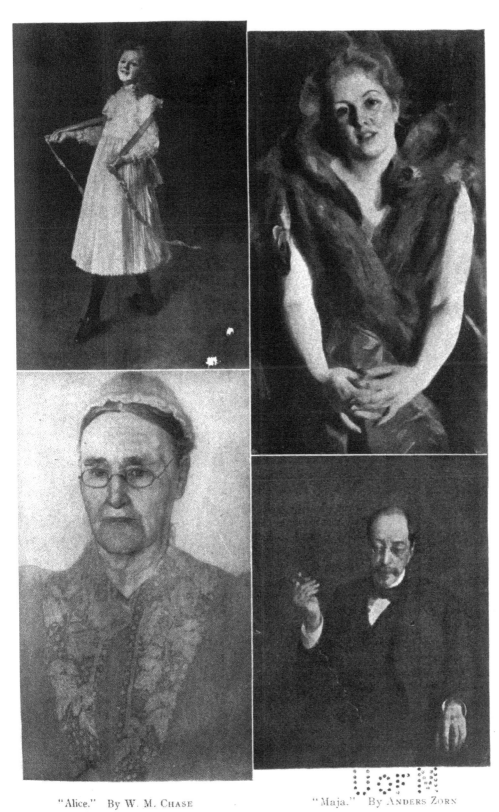

"Alice." By W. M. Chase "Maja." By Anders Zorn

Portrait. By W. D. Paddock "John La Farge." By Wilton Lockwood

Illustrations to Chapter I. The placing of the head

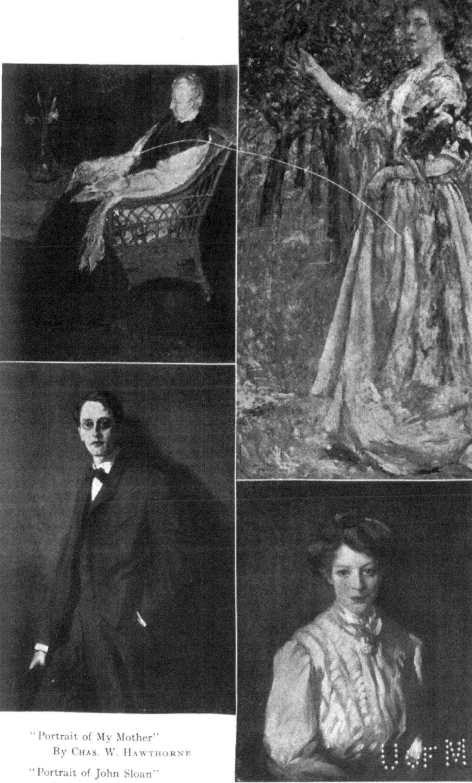

"Portrait of My Mother"
By CHAS. W. HAWTHORNE

"Portrait of John Sloan"
By ROBERT HENRI

Illustrations to Chapter 1.
The placing of the head

"Girl with Flowers." By ROBERT REID

"Girl with Red Hair." By ROBERT HENRI

Portrait Study

By Alvin Langdon Coburn

Illustration to Chapter I. The placing of the head

M to U

NE of the most, if not the most, important factor in arranging the composition for a portrait is the correct placing of the head. Without paying due attention to it the portrait is sure to prove a failure, no matter how technically perfect it may be otherwise. With it there is at least a chance of success; a basis is established to work upon.

Of course, it is a new problem with every new sitter, unless the photographer has solved these difficulties once and for all (as some have) by taking everybody in the same stereotype position, forcing the sitter into one of the five to seven regulation poses that he has at his command. Those whose ambition runs a little higher, and who like variety in their work, will have to solve the same problem over and over again.

We all know that every pictorial composition should have one point of interest, to which everything else is subordinated. In a portrait this is naturally the face. It may be the forehead, the eyes, the line of the profile—but that does not belong to this chapter. All that concerns us today is that the face should present a plane of such importance in regard to shape and tint as to immediately attract our attention. No matter how large or small a part of the picture the face forms, the

remainder of the space is dependent on it and will only look well if the face is placed in such a way that all other lines and light and dark planes are controlled and kept in perfect balance by it.

There are a few fundamental rules, and the very first one—which nobody can ignore with impunity—is that the face should never be in the centre of the picture. It always looks awkward; the face somehow gives one the impression of heaviness, of being out of place, and the rest of the picture is too symmetrical. It almost seems futile to mention this, as every photographer should know it, and yet there are studios all over the country that turn out, year after year, portraits (particularly of the vignetted style) with faces plumb in the centre. At one of the State conventions a photographer asked me why the centre arrangement was not as good as any other. I did not know what to answer, and finally said: "Perhaps it is for *you*—if your clients like it." Some people cannot be instructed; on the contrary, they seem to take a special pride in their ignorance.

There are exceptions, however, when the face in the centre looks as attractive as any other arrangement. One of them is when the face is very big, when it occupies one-third or more of the entire space allotted to the picture, as, for instance, in the paintings of Watts or some portraits by Day and Coburn, who at times make the head almost as large as the plate. In such cases the face necessarily will occupy the centre. Another exception I can illustrate by Harrington

22

Mann's portrait of "A Little Girl with Doll." This is an excellent composition despite the face being in the centre, because the interest is distributed over the entire figure of the little girl, and its pyramidal shape and varied half-tints form the right contrast to the background.

But in the majority of bust portraits we will find the face in the upper half of the picture somewhere near the centre. The great portrait painters of the Middle Ages established a certain principle, the so-called Golden Section (according to which all animal and plant life is supposed to be constructed and proportioned), and obeyed it in nine out of ten cases. The

system of the Golden Section is too elaborate for dis-
cussion. It would confuse my readers more than help
them, and this is just what I want to avoid in these
discussions. I will try, however, to convey the main
lesson that it teaches to portraitists. The principal

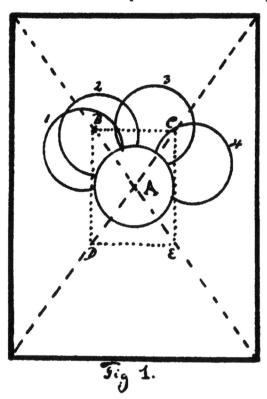

Fig 1.

accepted form for portraits is, I may say, an upright
oblong about 3 x 4. If you draw two diagonal lines
between the opposite corners, as in Fig. 1, and divide
both lines into three equal parts, you can easily con-
struct the smaller oblong *b c d e*. The face in nearly
all the portraits of Franz Hals, Titian, the English

portraitists, etc., and in our modern academical painters can be found somewhere along the dotted line in the upper half of the picture, generally in the region of the circles 2 and 3. Full-face and three-quarter views are rarely placed as low as circles 1 and 4. They are the domain of profile views and faces bent toward the ground. For centuries painters have adhered consciously or unconsciously to this law, and to follow it today is as safe and profitable as it ever was. Lockwood's "John La Farge" and Henri's "Girl with Red Hair" are two good examples—one of a large and the other of a small head. The white cross marks the centre of the pictures.

In seated figures the face is apt to be placed a trifle higher, as indicated by the three circles in Fig. 2. In standing figures the face is to be found somewhere in the upper triangle, still nearer to the top edge of the picture, viz., portrait of John Sloan, by Robert Henri. In some portraits of the Old Masters, for instance in the portrait of Dürer by himself, in the Prado, and some portraits by Hals at the Kassel Gallery, the top of the head almost touches the upper rim of the picture (as indicated in the dotted circles in Fig. 2). These, however, are not full-length figures, but only show the bodies of the sitters a little below the waist line. The head is, consequently, large and important enough to balance the rest of the picture. In full-length figures, as, for instance, in W. M. Chase's "Alice," the face could scarcely be placed any higher. Even as it is, it impresses one as being a trifle too high.

The lower half of the oblong is nearly always devoted to accessories and to the body of the sitter. An exception to the rule is Fig. 4, where, the head (or rather the hat) being of extra large dimensions, the largest part of the face may be put to advantage below the centre.

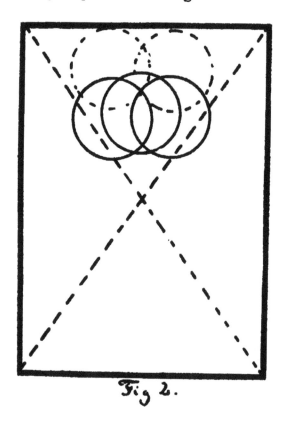

Fig 2.

This may sound all very simple to some of my readers, and so it is; but they should be so well acquainted with these facts that they would be no longer conscious of their existence. These fundamental principles should become second nature with them, and

rule their compositions without any effort on their side. Sorry to say, this is only the case in rare instances. Even the best of photographers at times ignore the laws of balance and proportion.

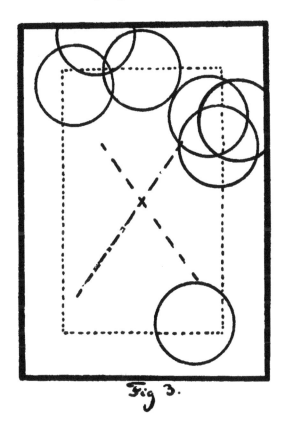

Fig 3.

: But what of those other pictures by Zorn, Hawthorne, Paddock, and Coburn, the Secessionist photographer, you may ask—they surely do not follow the rules that you have just laid down? There you are right. With the modern times a new note has come into portraiture. The so-called impressionistic style, as practised by the

Secessionists, has shifted the viewpoint somewhat. It is nothing new in painting. Everybody acquainted with the history of painting in the latter half of the last century knows that composition has undergone a change. It tries to be more natural and spontaneous, and does not care for tradition and conventions. It was the Orient, in particular the introduction of Japanese art, which proved to be the stimulant for

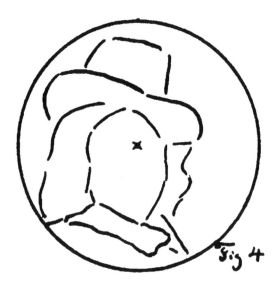

Fig 4

the innovation, and nearly all painters have adopted some of the principles of Japanese composition (strictly antipodal to the Greek ideals of symmetry which we had followed until then). Japanese art is unsymmetrical—this is the one best word which I can find to define it—and its influence on portraiture can be traced in the four portraits I just mentioned. In Japanese pictures the point of interest is generally nearer to the

edges than the centre of the pictures. It is somewhere near the dotted line in Fig. 3, and in the lower half as well as the upper half. The modern portrait painter, following this example, places the face as near the edges of the upper half of the picture as he possibly can (as indicated by the circles in Fig. 3); sometimes a part of the head even protrudes beyond the boundary lines of the picture.

Some even go as far as Raffaelli, who, in his portrait of Goncourt, placed the head where the circle is in the lower half of Fig. 3. I have never understood why, except he wished to make it look eccentric. In this he succeeded beyond doubt. In the drawing by Paddock you see how the face may dominate the entire upper half of the picture. (Holbein would either have raised the shoulder line or lowered the face a trifle.) In the "Portrait of My Mother," by Hawthorne, you will notice how a comparatively small head can be shifted in the upper corner of the composition. In the "Girl with Flowers," by Robert Reid, we meet a similar arrangement of the head for standing figures. Both pictures are more elaborate compositions than most photographers undertake to make, and the harmony of effect is solely due to this extra attention to details. In the Reid picture it is accomplished by letting the left edge cut into the figure. This treatment always accentuates the importance of the figure; isolates it, as it were, by producing a distinct shape to which the remainder of the space is subordinated. If the background was also visible on the other side of

the figure, even the merest trifle, the balance would be disturbed, as the figure in that case had to dominate both sides.

In the "Maja," by Zorn, a seated figure, it was only possible to place the face as high as it is by making the hands almost an equal point of attraction in the lower half of the picture. The portrait study by Coburn is typical of a certain style of composition that is coming more and more into vogue, of showing only a part of the figure or head, which is strictly of Japanese origin and practised by all impressionistic painters and Carrière among the portraitists.

All this is very interesting, but it is dangerous ground to tread upon, at least for the photographer. It needs a much more thorough knowledge of the treatment of accessories than the old style. And it is, after all, a question whether the old style is not the most satisfactory one, at least for portraiture (and portraiture only concerns us), and whether it will not win out in the long run. It is still practised by the majority of contemporary portrait painters.

A portrait (in particular a bust portrait) should be as simple as possible. It should explain itself at the first glance. We do not want to ask ourselves, How did the head come in such or such a position? There should be no contortions, foreshortenings; the head should not rest upon or lean against anything. What we want in a portrait is the face, and it should furnish without subterfuge the main attraction.

CHAPTER II

THE PROFILE VIEW

Portrait of the Spanish Painter Fortuny "Confirmation" (Painting). By E. Llewellyn

"Daisy." Amateur Photograph Portrait of Painter Westerholm

Illustrations to Chapter II. The profile view

Portrait. By CHAS. H. DAVIS Portrait. By C. RUF, Freiburg, Germany

Portrait. By H. MISHKIN Portrait. By DAVIS AND EICKEMEYER

Illustrations to Chapter II. The profile view

"Woman in Pink" (Painting) Portrait (Painting)
 By JOHN W. ALEXANDER By EASTMAN JOHNSON

"Bartholomé." By E. J. STEICHEN Profile Study. By F. S. WILLARD

Illustrations to Chapter 11. The profile view

MʔoU

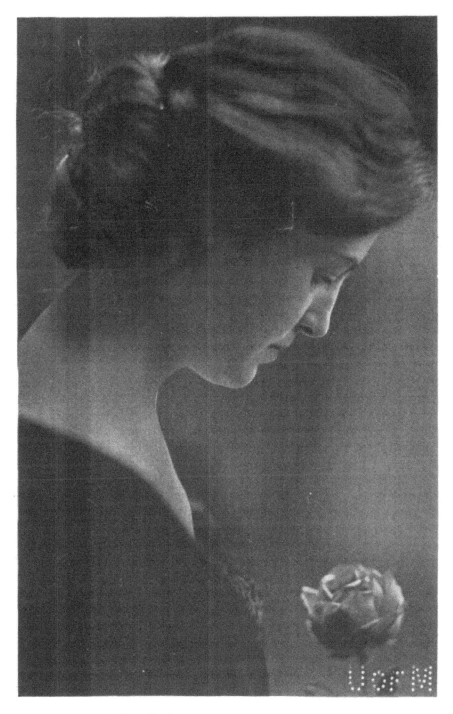

By S. H. LIFSHEY

Illustration to Chapter II. The profile view

4

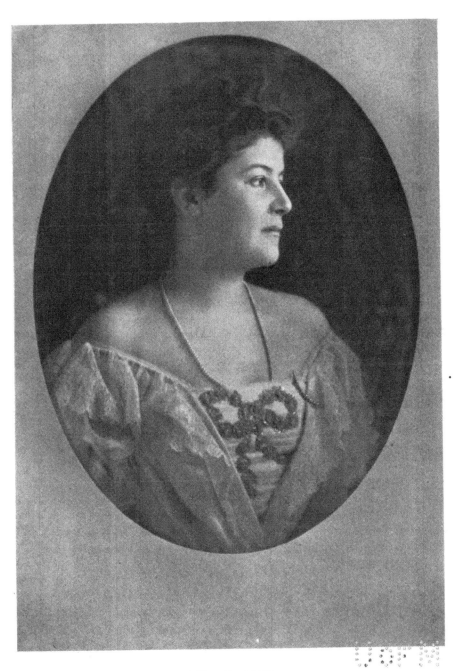

"Mrs. Rockhill"

Portrait by H. H. PIERCE, Boston, Mass.

Illustration to Chapter II. The profile view

HE absolute profile view, as seen on coins, making a clean line from the root of the hair to the throat, showing entirely one side of the face and nothing whatever (not even the suggestion of eyelashes) of the other side, is always interesting. Its principal charm lies in the uninterrupted line. For that reason sculptors use, with preference, the profile view in all medal and bas-relief portraiture. Modelling in low relief is really nothing but drawing with actual form, and the human face never yields a better line than in a profile view.

It, however, has its restrictions, particularly so in a black-and-white process. A profile is more limited in expression than the full-face or three-quarter view. There is but little chance for expression in the eyes and lines of the mouth. We are also apt to be more familiar with the features of a face in the variations of a three-quarter view than in clear profile. For the photographer (who primarily strives for likeness) it is, therefore, advisable to use the profile view only when it is specially characteristic of his sitter. And it is specially characteristic only when the line of the profile is either very strong, as in the head of the painter Fortuny and the portrait by C. Ruf (a German professional), or very delicate and pure, as in the painting

"Confirmation," by W. Llewellyn; or peculiar and out of the ordinary looking, as in John W. Alexander's "Woman in Pink."

Of course, there are people who desire a profile view even if their faces are not specially adapted for it, *i. e.*, neither perfect nor interesting in line. In

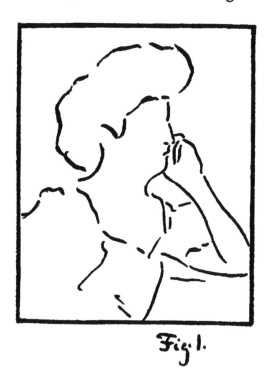

Fig. 1.

such cases it is well to hide the defects by placing, for instance, the hand at the chin, as in Fig. 1, or to arrange the hair in such a way as to form a subdued background to the line of the profile (Fig. 2). In a similar way the line can be broken by a broad-brimmed hat or a boa, as indicated in Fig. 3.

34

In the profile view only three positions of the head are possible. It is either looking straight ahead, or the face is turned upward, as in the " Bartholomé" (French sculptor), by Steichen, or turned downward, as in the portrait by Ch. H. Davis. The latter attitude is generally indicative of a pensive, restful mood.

It is very essential in both the upward and downward turn that the gaze of the eye be concentrated upon some object. A picture must explain itself. If the eyes gaze into vacancy, they are apt to lend a mournful, melancholy expression to the face, which is hardly desirable in portraiture. You will notice that the lady in Davis' picture is looking down at the flowers fastened to her corsage. It would be a better composition if she were looking down at flowers held in her hands. The facial expression would be a trifle more cheerful. A good example is also the portrait of Victor Westerholm, a painter at work looking at his picture. In the same way the gaze could be fastened upon a book, upon needlework, etc. The downward gaze is the only one possible in the downward pose of a profile head, at least in legitimate portraiture. As soon as the eyes in that peculiar position of the head would look straight ahead or upward they would express some human emotion, like curiosity, suspicion, malice, or mischievousness, and would not enter the range of portraiture, except it were the representation of an actor in a part which would necessitate such special expression.

The upward turn of a profile head is apt to express

a dreamy, exalted, or inspired disposition in the sitter. It is well carried out in Steichen's "Bartholomé," this sculptor contemplating his own work (he is standing under the portico of a tomb with gigantic figures); also in this attitude of the head the eyes can only look in one direction, namely, upward.

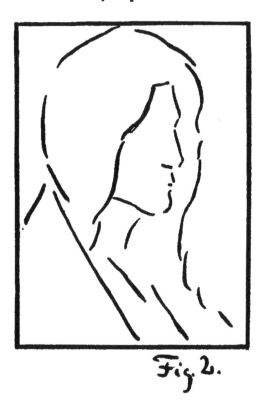

Fig. 2.

When the head is neither lowered nor raised, but in its natural position (as depicted on coins), the eyes look either straight ahead, as in the Fortuny, or downward, as in the Ruf portrait—*i. e.*, the eyes look as if they were closed, almost entirely covered by the eyelid

and lashes. The first is apt to lend an austere expression to the face, which will show few physiognomies to the best advantage. The latter gives a contemplative expression to the face, and is to be preferred in most cases, particularly with women. To make the person read a book, as in the "Confirmation," may often help the interest in the composition.

As said before, the profile view, no matter how it is arranged, is limited in facial expression. It is almost impossible to do anything with the mouth. An open mouth would be as much out of place as too tightly closed lips. Nothing else remains but the lightly closed or half-open mouth. Much can be gained by the position of the neck, for instance, by thrusting the face forward, as in the Alexander picture. Of course, this looks well only when the figure is shown. The "Woman in Pink" is in many respects an ideal profile composition. Everything—the line of the face, the neck, the arms and hands, as well as the arrangement of the dress—has been sacrificed to the beauty of line. The composition is photographically possible, but I do not remember of ever having seen anything in photography quite as interesting.

There are several variations of the profile view produced by a slight (at the first glance scarcely perceptible) turn toward or away from the spectator. Neither the portrait by Eastman Johnson, the bust portrait by Davis & Eickemeyer, nor the fancy head by S. H. Lifshey, is a perfect profile.

The woman's head in Eastman Johnson's portrait

is turned just a trifle toward the spectator. It shows a glimpse of the other eye and both lines beneath the nose. It subdues the severity of the line, accentuates the chin, and lends firmness and strength to the lower part of the face. It would help people with a weak

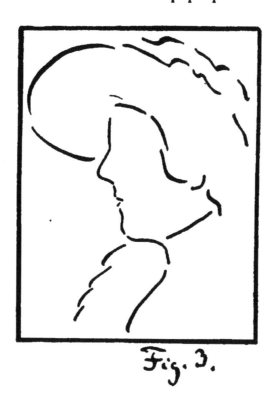

Fig. 3.

chin, but would hardly look well with a strong one. In the portrait of Mrs. E. V. Rockhill, by H. H. Pierce, the chin is too pronounced.

The position of the head in the Davis & Eickemeyer bust portrait is not a fortunate one. The upper part of the head is slightly bent backward and lowered,

by which movement the chin is raised. The pose is natural enough, but confusing, as it spoils the shape of the head.

In the Lifshey portrait the head is turned so far away from the spectator as to accentuate the cheek line. The girl looks pretty enough. Her face was probably specially adapted to this treatment. But in most instances the principal features of the face lose their definiteness by being too close together. The so-called three-quarter profile view (viz., the study by F. S. Willard) has solely pictorial value. Nobody would have his regular portrait taken that way, although the pose in itself is quite beautiful.

So far as the placing of the head in profile portraits is concerned, there is one rule that generally ought to be followed. There should be more space in front than back of the head. The Mishkin and Davis & Eickemeyer heads are badly placed. Also the East-man Johnson is not a perfect composition. Good in that respect are the Fortuny, the Ruf portrait, and the "Confirmation." Of course, there can be excep-tions to this rule, as the Alexander portrait, but there the lack of space in front is balanced by the backward position of the arm. Effective at times is the trick of showing only a part of the head, as in "Daisy" and the Willard study.

Much of the success of a profile view depends on the lighting. The most reliable way is from above, as in the Fortuny, Alexander, and Eastman Johnson. Light from the side, leaving the top of the head in the dark,

as in the Ruf portrait, is apt to lend a weird effect to the entire composition. When the face is not seen in full profile the play of light on the lips and chin becomes very important (viz., Mishkin). It really makes the picture. If the face looks downward and the light comes from above, as in the Davis portrait, the profile almost turns into a silhouette. If strong light effects are desired, it should be managed from below, as Lifshey did in his study.

In conclusion, I can only repeat: Never use the profile view unless the face of the sitter warrants it.

CHAPTER III

THE FULL-FACE AND THREE-QUARTER VIEW

Photograph Photograph

By HUGO ERFURTH, Dresden By C. RUF, Freiburg

"James Wardrop" "Thomas Carlow Martin"

By RAEBURN By W. Q. ORCHARDSON

Illustrations to Chapter III. The full-face and three-quarter view

M of U

"Laughing Girl"

By Franz Hals

"Burne-Jones"

By G. F. Watts

"Alexandre Dumas fils"

By Bonnat

"A Nobleman"

By Franz Hals

Illustrations to Chapter III. The full-face and three-quarter view

"The Leslie Boy"
By RAEBURN

"Mrs. Irvine Boswell"
By RAEBURN

"Mrs. Ferguson"
By RAEBURN

Study (Photo)
By DR. T. V. SPITZER, Vienna

Illustrations to Chapter III The full-face and three-quarter view

M to U

HE full-face view, in which both sides of the face are perfectly symmetrical, and in which the ridge of the nose is seen as two lines and not as one diagonal line against the cheek, has been used to good effect by the Madonna painters of old and also by many of the portraitists from Rembrandt to the present day. Reynolds was particularly fond of it. It does not lend itself quite as easily to photo-portraiture.

The full-face view with the head perfectly erect always looks a trifle stiff, and only a clever management of accessories and background can render it graceful. It depends too much on careful composition for ordinary use. If rightly handled, it is dignified in appearance, and the larger the head the easier it is to manage.

Another difficulty is the absence of strong shadows. A full face is generally seen in an even light. Of course, one can concentrate the light on the forehead and leave the rest in shadow, and light it from the side or from below; but even then the contrast of light and shade is less pronounced than in three-quarter views. For it is the nose that is the great shadow maker (I almost said trouble maker) in chiaroscural composition. In the full-face view, so long as it is seen under ordinary light

conditions, an even light distribution is the principal characteristic.

If you see a face out of doors against the source of light (Fig. 1), the face is darker than the background, but the values of the face are all seen in middle tints without strong highlights and shadows. The same relation of values exists, only *vice versa*, light against dark, if a face is seen under the normal light condition of an interior (Fig. 5). There is really no strong shadow except under the chin and sometimes, as in this case, under the nose. The Franz Hals picture is perfect of its kind and typical of a good full-face view. The slight inclination of the head takes away all stiffness and makes the figure more natural looking.

It is wonderful how much depends on the inclination of the head. The head carried perfectly erect is at 90 degrees. The Rembrandt head is at 80 degrees. A few degrees make a world of difference, and the most perfect poses are to be found in the section of 80 to 90 degrees. Nos. 3 and 7 show this; they are both taken at about 85 degrees. The head of the Franz Hals woman, mentioned above, is already tilted over a trifle too much for a portrait, while No. 10, "The Leslie Boy," by Raeburn, taken at 60 degrees, shows about how far one can go in inclining a head. It looks pleasant enough for a child, but would hardly look natural or graceful for a full-grown man or woman. There may be some who will dispute this, and, of course, there are exceptions, but I am certain that if my readers would examine the works of any portrait painter of

note they would find my statement correct. The head
is never seen at a lower angle than 60 degrees. I remem-
ber a portrait of Goya, by himself, in which the head is
thrown sideways to an alarming degree. It looks eccen-
tric, and everyone feels that it is no sane pose, and yet
the head is only seen at 65 degrees.

Vague charcoal lines in a background, indicating
80 to 90 degrees, would afford ample opportunity for
the study of posing a head. Try it; you will find it
profitable and learn a good deal from such experi-
ments. The difference of one degree makes an entire
change in the composition. The slightest tilt is notice-
able, and the slighter it is the more natural it really is.
It is easy enough to accentuate it by some vertical line
arrangement in the background.

It would be desirable if in all bust portraits the
management of the body, the lines of the shoulders
and arms would be kept as simple as possible. They
rarely explain themselves, as, for instance, in the
Orchardson portrait (Fig. 4). In most bust portraits
which show a good part of the upper body one does
not know whether the person portrayed is seated or
standing. A good portrait should never make one
guess at things.

In the Orchardson portrait one realizes that the
man is standing. The head is thrust forward in a way
that indicates a standing position. In the same way
you feel that Bonnat's Dumas is standing, and Franz
Hals' "Nobleman" is sitting. The elbow carries out
the idea. But look at the average of bust portraits

(photographs, I mean), and you will be utterly at loss. It is much simpler and much more beautiful to treat the body as we see it done in Figs. 3 and 6. In them the face is everything; nothing else counts. But how marvellously characteristic the faces are! I wish photo-portraiture would steer toward such a goal— the face in clear tints, seen in simple lighting, in a natural attitude, and everything else sacrificed to a happy expression of the face. And there is no modern portrait painter of whom photographers could learn more than of Watts.

The three-quarter view can be divided into four phases: First, where the view is almost a full-face view and the turn of the head is hardly noticeable, as in pictures 3 and 6; second, where the line of the nose begins to be seen sharply against the cheek, as in pictures 7 and 10; third, where the line of the nose touches about the middle of the cheek, as in picture 9; and fourth, where the line of the nose touches or protrudes over the outline of the cheek, as in pictures 8, 11, and 12. The best way to study this is to take a plaster-cast bust and turn it slowly from one side to the other.

I am of the opinion that the second and third kinds of view are the most popular ones. They offer the best chance for light and shade composition, and the human face is seen to the best advantage. It is the most interesting pose the average human face can assume. It shows everything a face contains in regard to line construction and modelling. And it has the charm of contrast, of decided highlights and deep

shadows. Of course, in photography there is the difficulty of making the shadow side look transparent and of not losing too much of the form. It is not in my province to give any hints how this may be accomplished (there are so many other men more able to do this than I), but I have observed that this shortcoming is no hindrance to the popularity of these two poses. Nearly eighty per cent. of all photographic portraits are made in that fashion, and for that reason I shall return in Chapter IV to these two views and try to dwell on all the manifold variations possible to them.

The three-quarter view which is nearest to the full-face view is the most artistic, as it is the most quiet one. It is least conducive to mere striving for effect, and always looks natural. It is less severe than the full face, as the perfect symmetry of the features is broken. The most ideal lighting for this view, I believe, is shown in the Watts picture, namely, sideways from above. As soon as the lighting is too much directly from above (Figs. 3 and 4) the nose loses some of its strength and the shadows under the nose and eye and at the corner of the mouth are apt to become too decided. It is effective in painting, as the differentiation of values can be produced by color. In photography it is more difficult to make the light line of the nose tell against a light cheek.

The more diagonally the line of the nose strikes the narrower side of the face the more picturesque the composition becomes. Also the eyes, so far as drawing is concerned, are seen best in the full or nearly

full-face view, the nose looks better in perspective, and the mouth better foreshortened. There is a sufficient variety of lines in these poses to render almost any face interesting.

Not the same can be said of the fourth kind of view. As soon as the point of the nose gets too near the outline of the cheek, as seen in No. 11, the line arrangement becomes a trifle confused. We are not used to seeing people that way. There is too much drawing, and we are, as a rule, not familiar enough with it (even where faces we know well are concerned) to make it look natural to us. This is particularly the case with women. The Dutch woman of Dr. Spitzer is surely no beauty, but it would be quite easy to get a more favorable likeness of her. Dr. Spitzer apparently wished to accentuate the ugliness, a peculiar ambition of many of our realistic painters.

A strong physiognomy, like Dumas by Bonnat, looks well enough, but we must not forget that a three-quarter view, as soon as the tip of the nose protrudes over the outline of the cheek, is almost a profile. This view in particular is only applicable to men with strong, clean-cut faces, but not at all suitable for handsome women or children. The best proof, perhaps, is that Franz Hals, in all his elaborate group compositions of guilds, committees, and riflemen associations, in which ten to twelve personalities or more are depicted, never employs the extreme three-quarter view for more than one or two.

CHAPTER IV

THE FULL-FACE AND THREE-QUARTER VIEW—(Continued)

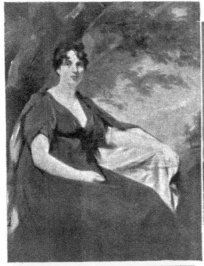
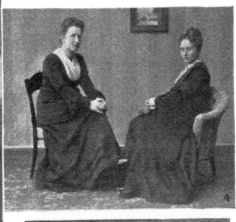
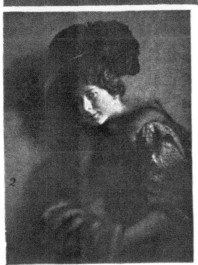
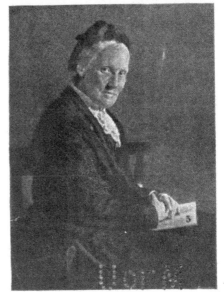

Portrait
By RAEBURN

"Two Sisters" (Photo)
By VON DÜHREN

Portrait (Photo)
By FRANZ GRAINER

Portrait (Photo)
By KÜHN

Illustrations to Chapter IV. The full-face and three-quarter view

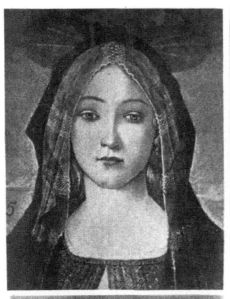

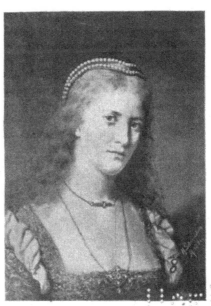

"Madonna"
By BOTTICELLI

Ideal Head
By CABANEL

Study Head
By SEIFERT

"Beatrice Cenci"
By SCHMIECHEN

Illustrations to Chapter IV. The full-face and three-quarter view

6

f moll

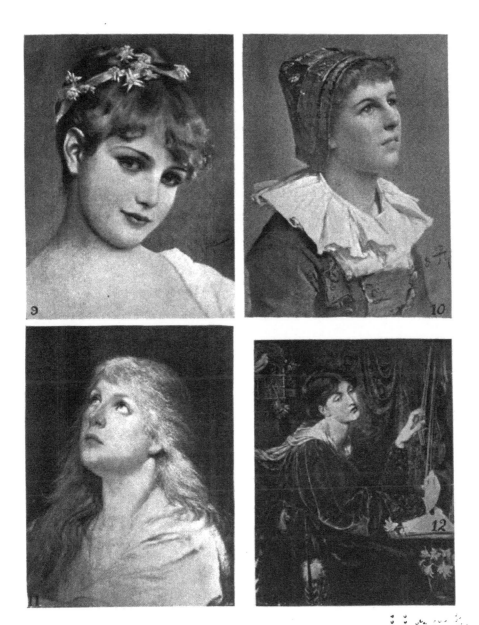

"Edelweiss"
By SEIFERT

"Madonna"
By GABRIEL MAX

"Peasant Girl"
By THUMANN

"Veronica Veronese"
By ROSSETTI

Illustrations to Chapter IV. The full-face and three-quarter view

E have agreed, I believe, that the normal three-quarter view, as seen in Figs. 4, 7, and 8, is the most popular, the easiest to manage, and also in most cases the most satisfactory one from an artistic point of view.

Let us now investigate when this particular view is seen at its best advantage. I have come to the conclusion that the simplest pose is always the best for portraiture, in this instance when the head is carried perfectly straight and easy, as in the Thumann painting (Fig. 10), or slightly reclining, as in Kühn's photograph and Schmiechen's fancy head of Beatrice Cenci (Figs. 3 and 8). As soon as you move the head in any direction, upward, downward, or sideways, you get a slightly distorted or at least less clear and convincing composition of the three-quarter view in question. By lowering the chin you get a composition as in "Edelweiss," pleasing enough, but you have to sacrifice the line of one side of the neck, and comparatively few faces can stand the exaggerated length of the jawbone from the tip of the ear to the chin. It also slightly foreshortens the region of the mouth and the lower part of the nose. The good taste of the photographer must decide these questions, a certain subtle instinct for what is right or wrong, whenever he sees a sitter

before him. Nobody else can do it for him. All I (and, for that matter, anybody who writes on the same topic) can offer are a few suggestions.

As soon as you turn the head upward or sideways the nose will become too prominent. Few persons would like to have their portraits taken in a position

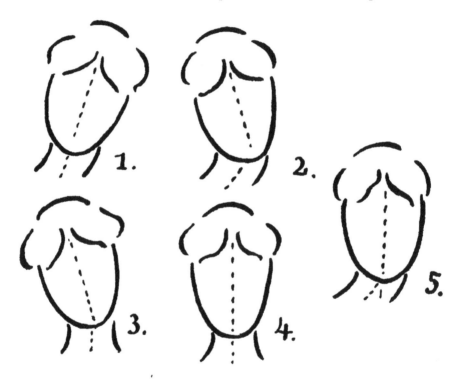

like Thumann's "Peasant Girl" (Fig. 10). The Gabriel Max is entirely out of question unless you want a Madonna and not a portrait. When the head reclines toward the shoulder, as in Rossetti's famous depiction of Veronica Veronese (and not away from the body, as is more frequently the case), the result is a highly

picturesque one. But I fear it would take a very long necked lady to be twisted into such a pose, and would suit only a particular type of beauty. What we want in photographic portraiture is common sense, natural deportment, and as little as possible of artificial posing. Even few actresses would assume such a pose without suggestion.

A pose as Franz Grainer, one of the leading photographers in Munich, Germany, has adopted from some modern portrait painting is much more acceptable (Fig. 4). It is a trifle "Secessionist" for ordinary purposes, but that is rather in the treatment, which is muddy; the pose in itself is absolutely natural, and although rather an unusual one, affords as good a three-quarter view as any. I rather like the way that Grainer used the shadow of the figure for the dark planes of the background, but it does not belong to this chapter.

Of particular interest seems to me to be C. J. von Dühren's (another German photographer) portrait of "Two Sisters." The picture teaches a lesson: it shows the difference of effect in the two principal methods of lighting applied to the three-quarter view. In one figure the light strikes the foreshortened side, and in the other the larger side of the face, that is turned toward the spectator.

If you prefer an even light and no decided shadows, the first manner (as seen in Fig. 2, in the figure to the left) will be the best, as it permits the play of middle tints on the shadow side of the face (Figs. 3 and 10).

The second manner will be always more contrasty, as the shadows of eyebrow, nose, and chin become more decided. Lighting, as in Fig. 7, is almost impossible in photography. The foreshortened side will rarely be as clear and clean-looking on both sides as in this "pretty" picture.

There are three normal positions for the eyes in the three-quarter view. They either gaze straight ahead into space (Fig. 7) or are turned slightly and look straight at you or the camera (Figs. 1, 2, 3, 4, and 9), or are fastened on some particular object (Figs. 10 and 11).

The latter is the least to recommend, unless the object explains itself in the picture. As soon as a person looks up or downward the pose begins to portray certain emotions, and the depiction of emotions does not belong to portraiture. Only very vague emotions, as, for instance, a cheerful smiling disposition—*i. e.*, traits that really belong to the physiognomy of the sitters as they are constantly displayed—these are permissible in portraiture. The dramatic element, even the sadness of lowered eyes or the astonishment of wide-open eyes, should be carefully avoided (at least in grown-up people).

The mouth as a vehicle of facial expression is almost as important as the eyes. But there is really little to say about it so far as composition is concerned. There is only one rule for both eyes and mouth—that they should be taken as naturally as possible. Of course, a mouth should never be too tightly closed and not too

much foreshortened, unless the foreshortened part
is lost in the shadow, as in Fig. 2.

A subject for careful study should also be the posi-
tion of the body in relation to the head. The three-
quarter view of the body is preferably the most effec-
tive for either profile, full-face, or three-quarter view.
A perfect profile of face as well as body is usually a
trifle hard and severe looking, and a full face with
a full view of the body easily becomes heavy and
uninteresting.

The face in profile and the body in full view is pos-
sible, but looks strained, as does a full-face view with
the body in profile. Such attitudes should be attempted
only when the sitters assume them, and I doubt if there
will ever be many who find any comfort in such wry
motions.

In the three-quarter view three combinations are
possible. The body can be in profile (as in Figs. 2
and 3, and in the figure to the left, Fig. 4), in three-
quarter (as in Figs. 1, 4, and 10), or in full view (as in
9). They all look well and have their advantages. I
personally might prefer the three-quarter view, as it
offers the best chance for easy and natural attitudes,
but this is largely a matter of taste. (And there must
be, after all, variety and lots of it!) The best way to
learn is to try and assume these attitudes and poses
with your own body and face before a mirror. I am
convinced you will learn more in half an hour than by
the study of a dozen books on composition.

There is still another combination, the head looking

backward over the shoulder. This is merely a variation of the pose in Fig. 3. The sitter only needs to turn the head a little more. The effect is always picturesque. It is also possible for the face in profile if the body is seen from the back. We will return to this in my chapter on standing positions.

There is still one particular phase of composition I want to speak about, namely, the composition of the neck. If well handled, it is sure to lend grace to every bust portrait. The most natural position is probably Diagram 4. Many of the early Greek statues and the Madonnas of the primitive painters, like Botticelli's head of the Virgin, carry their head that way. But it is not graceful, particularly in modern costume, and should be avoided as much as possible.

It could be easily improved by either giving the neck (Diagram 5) or the head (Diagram 3) a slanting position. A picture like Burne Jones' "The Golden Stairs" will give ample opportunity for such study and comparison. If the Thumann head (Fig. 10) were seen a little bit more full face, it would clearly show a straight neck and a slightly turned over face. Quite common and always pleasing is the effect of Diagram 1. It is well illustrated by the "Beatrice Cenci."

By far the most graceful of all poses is that of Diagram 2. It is really the ideal position of the neck, the classic standard as shown in the Diana's head of the Paris Louvre. A copy of it can be seen at any dealer in plaster casts. The portrait of Henry Raeburn and, in a more pronounced way, the ideal head of Cabanel

give a fair idea of it: of the oval of the face slightly turned sideways and set upon the neck in a position that the lines of the neck and face flow together in a curve. I would advise any photographer to pose as many heads as possible in this way. The line of the cheek and neck sloping away into the shoulder should make a blunt angle of about 100 degrees. I can guarantee that all heads carrying out this idea will be more graceful than the others that ignore it. Of course, it must not be exaggerated. The Rossetti picture shows an exaggerated version of the same principle.

CHAPTER V

THE MANAGEMENT OF HANDS

.

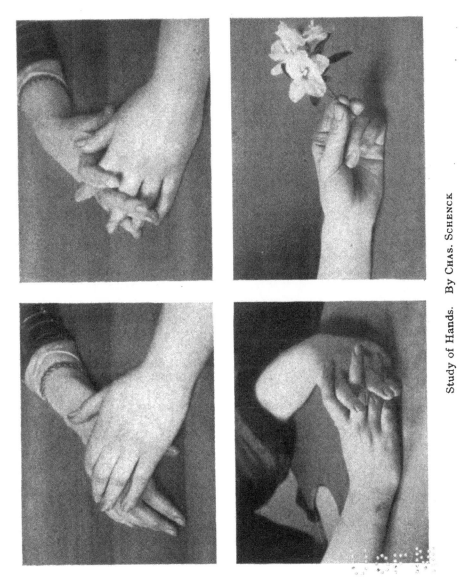

Study of Hands. By CHAS. SCHENCK

Illustrations to Chapter V. The management of hands

V to U

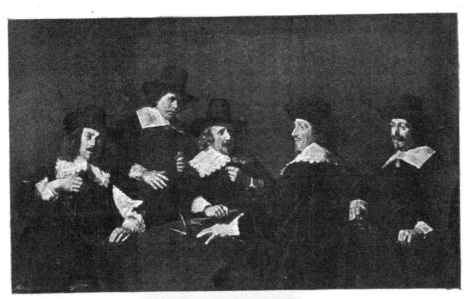

"Managing Committee of St. Elizabeth's Hospital." By Franz Hals

" Archduke of Saxony" "Isabelle d'Este" Portrait of a Man. By Titian

Illustrations to Chapter V. The management of hands

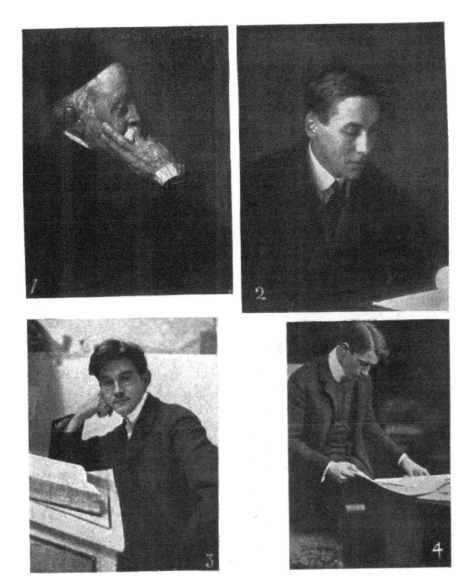

"Watts." By Steichen

Portrait. By C. Ruf

Portrait. By Bernoulli

Portrait. By Max Herber

Illustrations to Chapter V. The management of hands

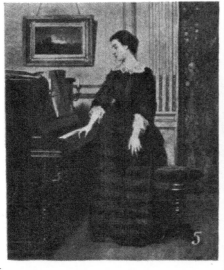
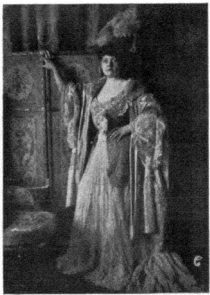

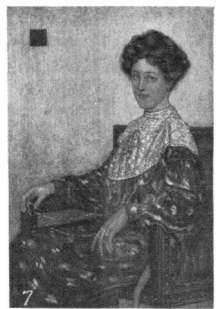

Lady at the Piano (Painting) Portrait
 By STEVENS By GRAINER

Lady with Jewel (Painting) The Violinist
 By JUNGMAN By C. RUF

Illustrations to Chapter V. The management of hands

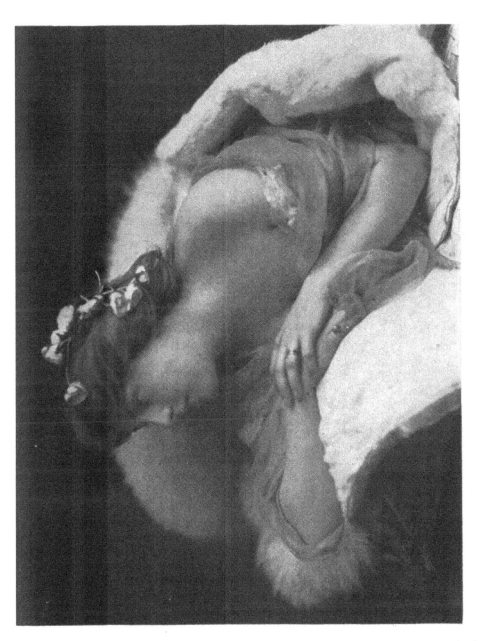

M 104

HE unsatisfactory rendering of hands is one of the drawbacks of photo-portraiture.

It is only on rare occasions that we see a well-shaped hand, well rendered, *i. e.*, correct in drawing (neither inadequately foreshortened nor disproportioned), definite and beautiful in all its details of line and modelling, and right in value, *i. e.*, neither too dark nor too light for the rest of the picture. I recall only few portraits in which the hands were as expressive and at the same time as accurate as in the accompanying studies by Charles Schenck. Even the extreme pictorialists fall short in this respect.

And there is an excuse for it, at least for those portrait photographers whose method and style of work do not permit them to devote more than ten minutes or so to a sitter. There is in every sitting so much to think of, and so much to arrange, that it becomes almost impossible to give the necessary attention to the posing of the hands. Many a photographer may realize the beauty of the human hand as a medium of expression, and yet not be able to carry out his ideas in regard to it.

And in that case I would say the best way would be to ignore them completely, to *leave them out*. I

7a

mean this seriously. Hands are not absolutely neces-
sary in a portrait. The Old Masters left them out
whenever they could, or treated them in the simplest
manner possible, as can be seen, for instance, in the
three portraits by Titian. The hands, at least in
these instances, did not seem to have caused much
perturbation to the Venetian master.

And yet if there was ever a school of painters who
valued the physiognomical significance of the human
hand, and were able to discriminate character from
the construction and outward appearance of the hands,
it was that of the Old Masters. They knew that the
whole gamut of human characteristics, of weakness
and strength, of timidity, kindness, anger, and their
opposites could be expressed by the shape of the hands,
for every good and evil passion stamps its impression
on the form and features of men, and each particular
passion has its own expression.

But this has nothing to do with portraiture, and
the Old Masters were aware of it. In their big com-
positions we find the most careful and elaborate ren-
dition of hands, for the figures in those pictures repre-
sent elemental emotions and passions, they are character
studies under special conditions of life, and do not
strive primarily for likeness. In portraits the hands
must be necessarily subordinated to the face. This is
an absolute law, that cannot be broken with impunity.

For that reason there are only three ways to approach
the subject: First, to avoid entirely the representation
of hands; second, to delineate them in the simplest

fashion without trying to show them in their most characteristic attitude, and third, to render them in a really impressive manner, to show their most salient features and the line and beauty of their construction.

The first method is not quite as easy as it seems, as the absence of the hands must not be noticeable at the first glance; it must be absolutely natural. Fig. 2 is a good example. The young man is reading. There is no doubt about that, every bit as much as Fig. 4. His pose is natural, and yet there is no evidence of any hands, and what is more strange, they are not missed. Their introduction would merely have interfered with the simplicity of the composition.

The second method is perhaps the easiest to manage. It should be left largely to the sitter; he should be made to drop his hands with perfect ease, or to place them as habit dictates, without the operator trying to force them into a special attitude. The only photographic law to remember is (so long as lenses are not made more perfect) to bring the hands into the same plane as the face.

The third problem, to give the hands a pictorial significance, is, of course, the most difficult one.

There are three reasons why a hand is difficult to take: First of all, on account of its intricate anatomical construction. There are too many angles, short undulating lines, and too many minute planes to permit anything but the most careful treatment. Besides, there is the overaccentuation of veins and furrows, which can only be overcome by tricks of elimination.

Nearly everything depends on the drawing. The out-line should be clear and at once explain the particular viewpoint from which it was taken, and the fingers should be always separated as much as possible from each other. Certain positions possible in painting are photographically impossible—as, for instance, the hand clinched into a fist, as in the Franz Hals portraits. They invariably look like stumps. All gestures with fingers bent or drawn together should be avoided. The hands should be posed as much as possible in a way that would give a full view of the dorsal surface of the hand with extended fingers (Fig. 5).

The full view of the palmar surface is rather scarce. It somehow lacks expression. The side view is the most animated and picturesque, and therefore strongly to be recommended, only not in full profile, as it then easily assumes the appearance of a claw (Figs. 5 and 7). But it is undoubtedly the most beautiful in line, allow-ing a variety of curves. The Franz Hals pictures afford a wonderful opportunity for the study of hand posing. They nearly exhaust the subject.

Another problem in the successful posing of the hand is the lighting. It is nearly always too dark. The hands in the large majority of portraits look like those of negroes. The trouble is that at present nearly all photographers strive too much for tone. They subdue them by force. To me this seems to be an error. I perfectly realize what consummate skill is required to bring the broken flesh tones of a hand into the right relation with the smoother surface of the face. Yet

I am of the opinion that they could be rendered in a much lighter key. If the shape of the hands is pleasing and interesting (as in Figs. 5, 7, and 8), its lighter value does not necessarily interfere with the importance of the face. Blotches would, but not well-defined shapes. In Fig. 8 the hands of the violinist could be a trifle lighter without harming the composition.

The third difficulty is one of costume. In men's coats (also often in women's gowns) the sleeves are nearly always too long. The hand without the wrist is not beautiful. It is rather clumsy looking. The Titian portraits of Isabella d'Este and Frederick of Saxony give an idea of it. The hands of the latter would look less large and fat if the painter had shown the wrists. This shortcoming, of course, can be remedied by pushing the sleeve or garment back, but it is only too often forgotten. The more there is seen of the arms the finer the composition can become in lines (viz., Davis' portrait).

To comment upon the pictorial significance of all the various attitudes that the hands can assume is, of course, an impossibility. A few hints must suffice.

Hands in a portrait should be either at perfect rest, for instance, lie folded on the lap, or listlessly touching the arm of a chair (Fig. 7) or should depict some arrested motion whose meaning everybody can understand at the first glance; for instance, a man seated at a table writing, or a lady gathering up the skirt or manipulating the train with a graceful twist. Poses as in Fig. 6, one hand supporting itself on a screen,

door-knob, mantelpiece, etc., are natural enough, but are apt to take away some interest from the face. The poses should never suggest real action or gestures characteristic of a particular individuality. The portrait would change at once into a story-telling or genre picture. A girl eating candy or fruit is no longer a portrait. The same may be said of women holding their hands behind their head, arranging their hair, etc. Such pictures have a decorative tendency, and will only do for fancy heads and ideal studies.

Holding a fan, a flower, a book, etc., is always effective, but I draw my line at statuettes and crystal balls. Those objects belong exclusively to the paraphernalia of the Secessionists. Photographers seem to be very fond of photographing people playing the violin and the piano, and they are right. There the hands become almost the main purpose of the picture, and as the nature of the process of playing affords great pictorial possibilities, the depiction of musicians with their instruments is really an ideal domain for hand photography.

The hand used as a pendant to the face (Figs. 1 and 3) is a modern adjunct to portraiture. Either the palmar (Fig. 1) or the dorsal surface of the hand (Fig. 3) is applied to the chin, forehead, or cheek of the face. It hardly ever helps the delineation of character, but is merely a mannerism of composition applied principally to produce a more picturesque effect.

CHAPTER VI

STANDING POSITIONS

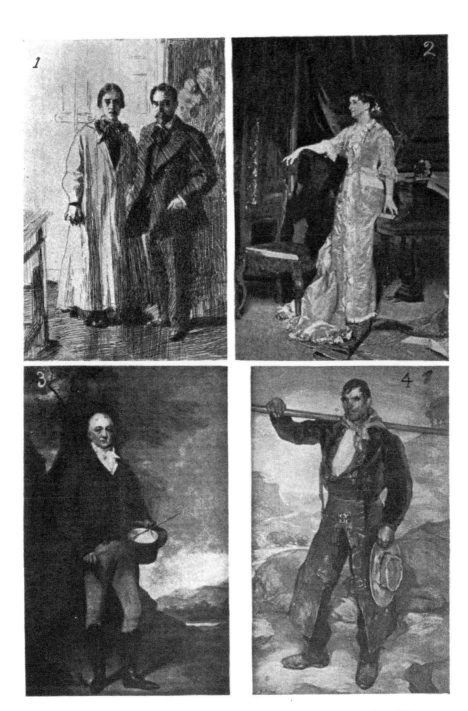

"Mr. and Mrs. A. Curtis"
(Etching). By Zorn

Portrait
By Raeburn

"Madame de Somziè"
By Emile Wauters

"Keeper of the Bulls"
By I. Zuloaga

Illustrations to Chapter VI. Standing positions

Portraits. By Franz Grainer

Illustrations to Chapter VI Standing positions

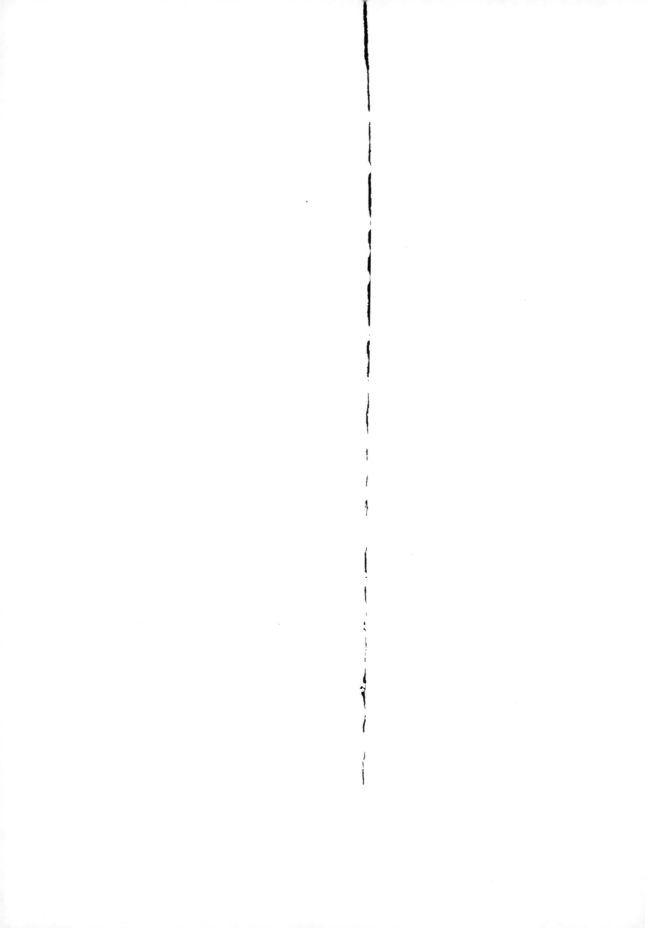

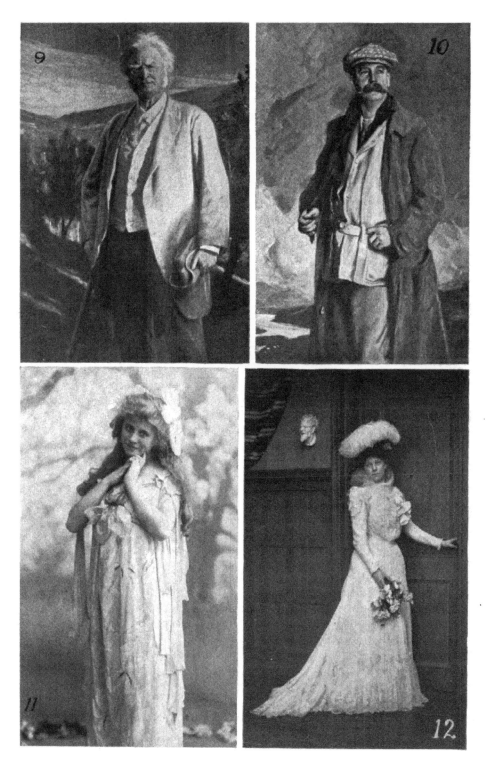

Portrait: "B. Bjornson." By P. S. Kroyer Portrait. By Richard Jack

Photograph. By Davis and Eickemeyer Portrait (Photo). By Bradley

Illustrations to Chapter VI. Standing positions

I N full-length standing figures the position of the legs and feet is of the greatest importance. If a man or woman in a standing position does not feel at perfect ease, the whole figure is apt to look awkward.

People under the skylight should be allowed and induced to stand in absolutely natural attitudes, *i. e.*, attitudes natural to them when they are at home and unconscious of posing. True enough, sitters are not apt to fidget about their feet as much as about their hands, but they easily fall into awkward positions, and it remains for the photographer to discriminate whether they are accidental or individual attitudes.

Nobody would call the way Mr. and Mrs. Curtis (Fig. 1) are standing graceful, but it looks natural, and one feels that it is characteristic of them. In Fig. 2 we have just the opposite. It is a beautiful picture, and the figure a clever bit of composition, but it looks *posed*, and even a trifle theatrical.

Photography has to answer for many absurd attitudes, as, for instance, the one of Diagram *E*. We are all acquainted with it. It is in ridiculously bad taste, and surely not natural. The pose occurs in statues, but when it does occur a staff or some other support is given. How it should ever have become popular

8

in photographic portraiture is difficult to explain, as a man in modern garb rarely assumes that attitude unless he is leaning on a cane or something. But, even then, imagine how foolish Bjornson (Fig. 9) would look if he had crossed his legs in that fashion!

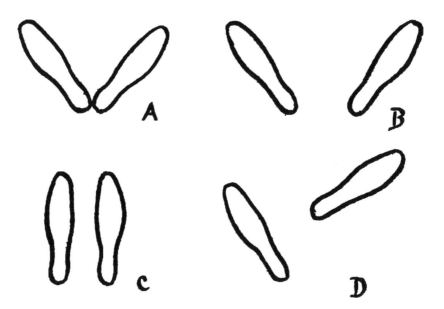

There are really only very few positions of graceful standing. They might be divided into four: First (Diagram *A*), where the feet form a right angle, the heels touching each other (Fig. 1). It lends firmness to the carriage of the figure. Second (Diagram *B*, Fig. 1), the feet separated, but otherwise the same as in *A* (Fig. 9). Of course, one or the other might be advanced or drawn back a trifle; all I want to indicate in this analysis is the principal characteristics of the various positions. Many men are in the habit of stand-

ing that way. It demands careful management of the arms to balance the straightness of the legs. Women do not look well that way, excepting young girls dressed for some outdoor sport; for instance, holding a tennis racquet in front of them. The position of the feet in Diagram *C* is a distinctly feminine one. Fig. 2 might stand that way. It only suits certain women and certain attitudes. Diagram *D* shows the most normal position. A naturally graceful person always stands in this fashion, and all other persons whenever they are graceful. Watch for that moment when a straight

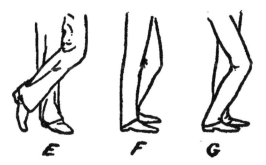

E *F* *G*

line from the toes to the heel of the advanced foot would cut the centre of the other foot at a right angle, and you will always have the sitter in a graceful position. You will notice that the old English gentleman in knee breeches (Fig. 3), as well as the gaunt figure by Zuloaga (Fig. 4), a crude, rough type of a Spaniard, have been placed in this position. You can absolutely rely upon this rule, that whenever the feet are in the right position, the body will follow suit. All good actors are aware of that fact.

Graceful persons generally let the weight of the body be borne by one leg, and advance or draw back the other one. This throws out the hip of the leg which bears the weight and gives a picturesque swing to the whole body. You see this plainly in Grainer's excellent portrait (Fig. 8).

The most appropriate view of the body in full-length standing figures is the three-quarter one. A standing figure seen entirely in profile does not look well, and I do not recall at the moment a single instance when it has been attempted in portrait painting. Nearly all the pictures illustrating this article show the three-quarter view. Figs. 5, 6, and 8 show almost a full front view. Although exceedingly picturesque in 8, this viewpoint is usually not as favorable for pictorial composition as the three-quarter one. It is apt to look heavy. No doubt Fig. 8 would look that way without the fur mantle and the clever light distribution. In Fig. 7 we have the lower part of the body and one arm in profile, while the upper part of the body is seen at three-quarters. This lends variety to the composition, and experiments in that direction are to be recommended.

Diagrams *F* and *G* show a man's legs in profile. In *G* there is more chance for a clever arrangement of lines, but I believe that for ordinary purposes the leg nearest to the camera should be the straight one. It obliterates the double curve, and there are so many people who object to bent legs.

A standing figure either stands absolutely free without any support, or is leaning against or supporting

72

its arms upon something. In my opinion the first is to be preferred. A standing figure should simply stand. A leaning position, as we see in Fig. 5, is not particularly graceful. The slant backward, although cleverly managed in this particular portrait, would be detrimental to the lines of most figures, excepting very tall ones. To support the arms on some piece of furniture or other demands extra care in the arrangement of arms and hands and a lot of really unnecessary paraphernalia. In home portraiture it may prove advantageous, but in studio portraiture meaningless poses, as in Fig. 7, are to be avoided. Also, the arms should be made as little conspicuous as possible. Let them hang down naturally, as the woman in Fig. 1. It always looks well. Or let them be occupied in holding something, as in Figs. 3 and 10. One arm akimbo (Fig. 8), or one or both hands in the pocket (Fig. 1) or resting in the belt (Fig. 10) are effective poses; 6 and 7 are pretentious and meaningless, and 11 and similar affected poses are only good for theatrical portraiture.

The simpler a figure stands the better it is for a portrait. Figs. 9 and 10—one an eminent author, and the other a war correspondent—show such simple characteristic attitudes. The poses should never mean anything in themselves; by this I mean that in looking at a portrait one does not want to ask one's self why the figure is standing in such and such a way. It should merely show us the man or woman in one of their most characteristic attitudes. Figs. 6 and 7 are bad in that respect. Of course, at times the suggestion

of some arrested motion, as in Fig. 12, may enhance the pictorial value of the picture. She is just reaching for the door-knob, ready to leave the room. It has not harmed the portrait proper, as the suggestion of action is subordinated to the likeness, but neither does it help it; and it would take very little to change the portrait into a story-telling picture.

I consider standing figures seen to the knee only more desirable in photographic portraiture than full-length ones. A full-length figure really needs some special environment. It should be seen in a room or out of doors, or the feet will look awkward. They have such a wicked tendency to look larger than they are. A knee portrait in most cases will serve the purpose just as well, and is easily brought into harmony with an ordinary background.

But whatever you do, do not screen off the light entirely from the feet, or darken them into indistinctness by rubbing them down on the negative, or, what would be still worse, vignette them off.

My observations in this article only apply to standing positions of grown-up folk. To the feet of children more latitude of expression is allowed.

CHAPTER VII

SITTING POSITIONS

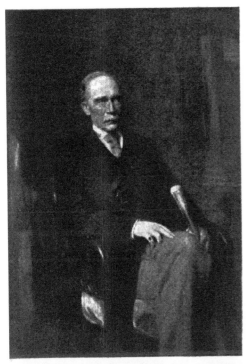

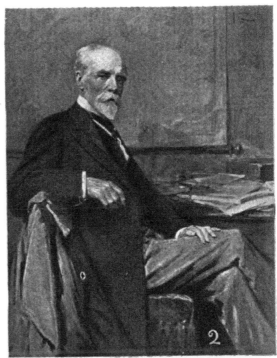

"George von Bunson"
By Reinhold Lepsius

"The Silver Mirror"
By W. Graham Robertson

"Hon. Whitelaw Reid"
By Sir George Reid

Portrait
By MacMonnies

"Mlle. Cremer"
By Emile Wauters

Illustrations to Chapter VII. Sitting positions

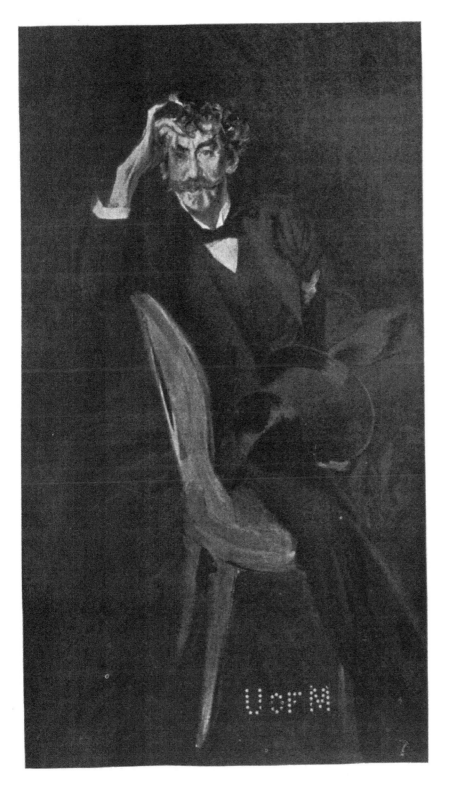

"Whistler." By BOLDINI

Illustration to Chapter VII. Sitting position

I N the last chapter we have observed that the full profile view does not lend itself particularly well to standing positions. This does not hold good with sitting positions. They somehow find their most favorable expression in a clear profile from the forehead to the tip of the shoe.

It is not a mere coincidence that James McNeil Whistler painted his two masterpieces of portraiture, his "Mother," at the Luxemburg Galleries, and his "Carlyle," which we reproduce, as profile views. A seated figure is generally a jumble of lines. Treated in profile, the lines become simplified. Only one arm is seen in its entire length, and the lines of the legs can be more easily managed.

The great difficulty of depicting a man seated is caused by his legs. It is almost impossible to make these two pieces of stovepiping fall into graceful lines. And comparatively few sitters take enough exercise to keep their limbs supple enough to assist the operator by placing them in graceful positions. When a man sits in a chair, after a time he feels inclined to rest one leg by crossing it over the other. This helps considerably to get rid of the two parallel lines formed by the lower ends of the trousers. The two most natural ways of resting one leg on the other are shown in the

diagram. *A* is, no doubt, a graceful position, but it is only suited to a certain type of "young and stylish" men, and does not lend itself particularly well to photographic portraiture. The lower part of the picture is generally dark, and this (unless very skilfully handled) will result in one leg, the one touching the floor, being almost lost in tonal darkness, while the other, by the nature of its position, will receive an undue share of light, and easily look out of proportion. *B* is by far the most common pose. Everybody assumes it. Some

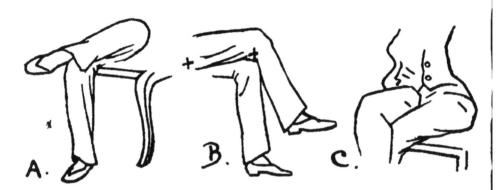

photographers think it objectionable, because it often makes such a long straight line from + to +. By getting the sitter to cross the outer leg over the nearer one (*C*), this line is got rid of; but this position, on account of its foreshortenings, is much more difficult to take. And, after all, the other can be managed successfully, as we see in the portrait of Whitelaw Reid.

To return to the full profile view. I would like to draw special attention to the "Carlyle." It is a most

formidable object lesson. No better picture could grace the walls of any studio. The majority of photographers have fallen into the error of looking at the Old Masters for inspiration. A few pictures of Whistler, Alexander, Sargent, Zorn, Lenbach, Bonnat, contain more instructive qualities for the up-to-date photographer than all the Old Masters that can be found in European galleries.

Notice how sure, simple, and well-balanced the composition of the Carlyle is; how all the details of dress have been eliminated; how the outline has been accentuated against the background; how naturally the figure is seated, and how well it has been placed in space. There is an atmosphere around the figure. One feels that this person is seated in a room. How few photographs can carry out the atmospheric effect! (The gloved hand resting on the cane is a trifle too dark, but that is only the case in the reproduction; in the original the color value of the glove tells beautifully.)

A seated person in profile looks contemplative, unconcerned, isolated, as it were. Looking straight ahead, the person seems to live in a world by himself. The aspect is a trifle stern. But for a serious portrait of an old man or woman, or a personality of prominence, no better viewpoint can be found. It is simple, dignified, and decorative at the same time.

The other views have a more picturesque tendency. In Fig. 2 we have the body in profile and the face in three-quarter. This view is one of the most satisfactory ones. The simplicity in the handling of the body

is preserved, while the face turned toward us has a more sympathetic, cheerful expression.

Fig. 1 gives us a full three-quarter view. It has the charm of being more pictorial. The lines are softer and have more swing to them. It is the ideal position for women. The lines of the skirts flow more gracefully (particularly so if the gown has a train) in this position than any other. It affords a wonderful opportunity for diagonal line arrangement.

Figs. 3, 5, and the famous portrait of Whistler, by Boldini, show us the full front view. The simple full front view, the legs straight down, as exemplified by the MacMonnies portrait (Fig. 3), is always a trifle bulky and awkward. There is too much symmetry and too many parallel lines. This can only be improved upon by special lighting, as we see in Fig. 5 (by the by, not quite a full front view), or by placing the arms in such a way (viz., the same portrait) as to break the symmetry. If the arm of this lady were hanging down, as in the MacMonnies portrait, the composition would suffer and the portrait would look rather commonplace. A still more effective way than the mere shifting of the arms is to give the entire body a peculiar twist or swing. This Boldini accomplished in his portrait of Whistler. This portrait competes in excellence with that of Whistler's "Carlyle." It is picturesque in the extreme, almost too much so. One thing is sure: If you ever succeed in placing a sitter in a similar position, you will have one of the most successful pictures you ever made. But I fear you will have to wait until

a person comes to your studio and assumes such a position naturally by his or her own free will. One cannot force people to look picturesque. It would prove a dire failure. The Boldini portrait, however, shows that the general awkwardness of the full front view can be overcome, and to the photographer who sees and thinks it will suggest an endless variety of new poses. The difference between the Boldini and Mac-Monnies portraits is too startling to be overlooked. Both are natural, but one is prosaic, ordinary, while the other one is interesting and full of animation and life.

There is still another view, which in itself is more picturesque than any other. It is the three-quarter back view, with the face looking over the shoulder. It is specially suitable for women, and always sure of a pictorial effect.

Before I conclude this chapter I would like to talk a few minutes about the most necessary adjunct of all sitting positions, namely, the chair. It is the real stumbling block in the majority of unsuccessful portraits of this kind, and there are few photographers who could not tell their own tale of woe about this most obtrusive and unwieldy piece of furniture. In appalling distinctness, its arms and legs appear always where they are least wanted. One might almost suppose that an ordinary piano stool would prove the best vehicle to overcome all these difficulties. But, after all, there must be some visible support to a seated person (depicted in full length), and it would be impos-

sible to manage the backs and arms of the sitters without the backs and arms of the chairs. So there you are. The chair is a necessary evil. But I really do not understand why those huge carved monstrosities of studio armchairs, with a back twice as high as that of any chair in ordinary use, have ever come in vogue. They mean death to any portrait with artistic pretensions, and the photographers who patronize them are in misery indeed—and by their own doings.

My advice is to show the chair as much in profile as possible, as in the Whistler and Boldini portraits. It does away with the confusing perspective of the legs. Of course, you can subdue it, as in Fig. 1, or disguise it with drapery, as in Fig. 2. But one means extra work, and the other somehow never looks right. People don't drape their chairs in ordinary life; why, then, should it be done in portraiture?

Much trouble could be avoided by selecting simple, graceful, fashionable chairs, such as are used in everyday life. Their lines must mean something in the general composition, and as much care should be bestowed upon their arrangement as on the arms and hands and legs of the sitters. And why must it always be a chair? A settee, a sofa, will yield in many instances much finer opportunities than the stiff and awkward studio chairs.

CHAPTER VIII

ON BACKGROUNDS

Illustrations to Chapter VIII. On backgrounds

Illustrations to Chapter VIII. On backgrounds

M to U

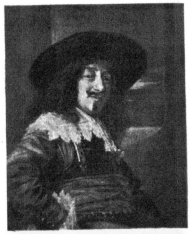

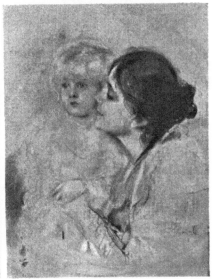

"Portrait of an Admiral"
By FRANZ HALS

Portrait (Photo)
By R. DÜHRKOOP

"My Mother"
By LUDWIG MICHALEK

"Eleonora Duse and Marion Lenbach"
By FRANZ VON LENBACH

Illustrations to Chapter VIII. On backgrounds

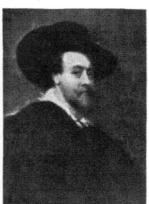

"Burne Jones" "Self-portrait"
 By F. Hollyer "Lady Gavagh" By Rubens
 By Watts
 "Miss Simpson" "Colonel Scott"
 By Raeburn By Raeburn

Illustrations to Chapter VIII. On backgrounds

IR JOSHUA REYNOLDS is often quoted as having said that the background is the most important and difficult part of a portrait. This is, no doubt, a slight exaggeration. The rendering of the face and figure is, after all, the principal thing.

But nobody will deny the difficulty of making a background simple and unobtrusive, and yet effective, so that it will form an harmonious part of the picture and show the head and figure in a way that one gets the impression as if they were surrounded by space and atmosphere.

There are really only three kinds of backgrounds: First, the simple, plain background, which consists merely of a differentiation of values, a gradation from black to white. Second, the artificially arranged or studio background, that deals with accessories and introduces lines and forms into the play of light and shade. And third, the home portraiture background, which tries to make the best of the momentary environment.

I shall deal largely with the first, because it reveals the fundamental principles that underlie the making of a background better than either of the other two. The same laws that apply to the plain background

also apply, with few modifications, to the studio and home portraiture backgrounds.

At the very start I must confess that there are no distinct rules to go by. In the profile and three-quarter view I was able to assert that such and such a view was the most favorable one. It is impossible to do this with backgrounds. They depend too much on the complexion of the face; on the color and form of the hair, headgear, and wearing apparel; on the particular silhouette the sitters make against the space behind them, and the general arrangement of lines and light and shade of the composition. It is a new problem in each instance.

There are, however, a few background arrangements that are typical, as they have been in use ever since portraits were made. I have tried to reduce them to the eight forms shown in the diagrams. Of course, the light spot in Diagram 1 could just as well occur on the right side, and all the various arrangements could be entirely reversed; that is, for instance, in Diagrams 3 and 4 the light part could be dark, and *vice versa.*

A background (excepting those of absolute monotone tints) always consists of two masses, one lighter than the other. The lighter one is generally the smaller. The separation of the two masses is produced merely by a juxtaposition of tints; one feels that they are separated, but one cannot say where either ends; they glide into each other by the means of more or less subtle gradations. At times they may look like a mere

jumble of black and white, all mixed up in their planes, but even then one should be able to trace vague shapes of light and darker masses. It is always the same struggle between light and darkness. The all-dark or all-light background (one single tone without differentiation) is the simplest type. A plaster cast looks well against a solid black ground, and a bronze bust against a monotone middle tint, but it will never do in portraiture. The Secessionists and extreme tonalists have often fallen into that error. There must be somewhere some slight differentiation of values, some accidental light, some passing shimmer, some apparently meaningless spots or accents, or the surface will look dead and the figure as if pasted on the background (if the latter is light) or entirely lost in the background (if dark).

A narrow strip (Diagram 5), either darker or lighter than the remainder of the ground, along the top or bottom of the picture (and for that matter also along either of the upright sides), is often used effectively. It looks rather bold, yet furnishes an accent and helps the background to recede in the picture and to suggest space behind the figure.

The most popular form of a background is shown in Diagram 1. We all know it. I venture to say that seventy-five per cent. of all background arrangements are made on that principle, *i. e.*, to show the lighted part of the face against a middle tint plane and to surround the head with more or less darker planes. A variation of this principle is shown in the Mrs. Simp-

son, of Raeburn. The strongest highlights in the figure occur in this instance in the side that is ordinarily shown in shadow. The result is a stronger contrast against the dark planes of the background.

Diagrams 3 and 4 show backgrounds that were extensively used by the English portrait painters. They have been so much tried and so successfully that they cannot help being effective. In Dührkoop's portrait we have the arrangement of Diagram 3, and in Watts' "Lady Gervagh" and Raeburn's "Colonel Scott" the reverse of the same. Any art magazine or illustrated history of art will prove the popularity of these two forms of background. Diagram 6 is particularly suitable for decorative work or when the head is small and you want a similar effect on both sides of the figure.

The arrangement in Diagram 2 is capable of the most artistic effects. It was applied with preference by the Dutch portrait painters. The idea is that the light spot is a trifle larger than the head of the sitter. This will allow slight patches of light on both sides of the head. If you place the lighted part of the face against the darker part of the background, you have the famous Rembrandt effect. The Rubens self-portrait is composed on that principle. Of course, no picture reproduced here carries out exactly the shape and values of the black and white arrangements of my diagrams. I merely have endeavored to come down to typical forms that are the basis of subtler and more elaborate arrangements. If half a dozen

pages were put at my disposal for the reproduction of paintings, I could absolutely prove to you the correctness of my theories. As it is, I can merely make some suggestions and leave the remainder to your own investigation. We ought never to forget that composition cannot be taught like a language. After all, we only know and appreciate such ideas and facts as we have gathered from our own observations and experience.

In Diagrams 7 and 8 I show you two backgrounds that are frequently applied by modern portrait painters for standing figures. Whistler, Chase, and many others seem to be particularly fond of the arrangement in Diagram 7. If the floor is lighter than the rest, the result is a distinct contrast between foreground and background. It helps to suggest actual space the picture gives in prospective depth, and the figure is enveloped, as it were, in vibrating air. Diagram 8 is simpler and shows merely that if the floor is as dark as the space behind the figure, a lighter spot must occur somewhere to break the monotony of the background composition.

As for the background with accessories, it seems that the old masters carefully avoided them in their portraits whenever they could. A background should be simple first of all. They were, however, fond of vertical lines, and frequently introduced an open window in one corner of the picture. This suggested an interior, and as the space occupied by the window and the landscape outside was invariably in a lighter

key than the rest of the background, it helped the chiaroscural part of the composition. The Dutch masters, striving for more picturesqueness, did not hesitate to put the window right behind the head of the sitter, as in the "Portrait of an Admiral," by Franz Hals. But if you study it carefully you will realize that it merely is a version of the arrangement in Diagram 4. And in all the elaborate landscape and curtain and column arrangements of the English portraitists you will find the same. It can always be traced to the contrast of dark and light planes, and the juxtaposition of black and white in spots and masses.

The old window idea, reduced to a vertical line division of dark and lighter planes, is cleverly used by modern portraitists. A good example is Hollyer's portrait of Burne Jones.

The home portraiture background will always look a trifle amateurish unless superior knowledge of composition is applied. I fear the depiction of an interior like Michalek's "My Mother" is photographically an impossibility.

The plain background is always to be preferred. The sketchy background, as applied, for instance, by Lenbach (which still belongs to this category), opens up new possibilities. A few scratches and daubed-in accents are apparently all. And yet, as unimportant as these technical details may seem at the first glance, they lend virility, variety, and comprehensiveness to the total effect. With their help an otherwise dead surface becomes animated, the silent begins to speak,

and the dull turns colorful. But only a trained artist can do it, and it is largely a matter of temperament.

The trouble with the painted-in backgrounds that have lately become so fashionable in photography is that they are not made by trained artists. They are merely indifferent imitations of the backgrounds of well-known paintings, and often in no light relation whatever to the subject depicted.

It is probably hardly necessary for me to say that the silhouetted and air-brush backgrounds are no backgrounds at all, artistically speaking. They may have their commercial value, but no pictorial pretensions whatsoever. They are in as bad taste as the carved arm chair, potted palm, and *papier mache* column of former periods.

The simple, plain background will win out. It is the most normal and dignified of backgrounds. I still may add that the lighter a background is the more cheerful and pleasant it will look, while a dark background will suggest depth and be sure of a more serious and dignified effect. The vaguer the differentiation of values the more refined and elegant an impression the background will give; on the other hand, if you strive for brilliancy, the contrasts between dark and light must be more pronounced.

Yet remember that it will be a new problem with every sitter, with every pose, and for that reason, if for no other, it is well to speculate in a few of the most typical forms, as I have endeavored to do in this chapter.

CHAPTER IX

ON THE ARRANGEMENT OF GROUPS

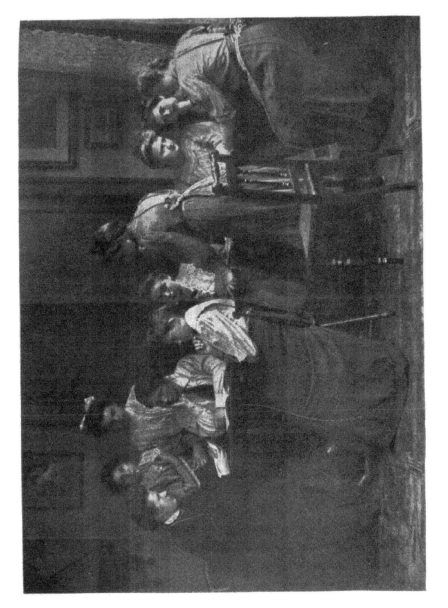

Academy Group.

By WILHELM KUBELER, Darmstadt, Germany

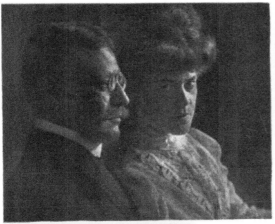

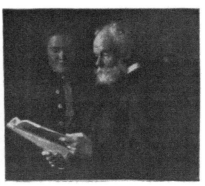

Portrait Group
By Franz Grainer

Portrait Group
By C. Ruf

Portrait Group
By Gertrude Kasebier

Portrait Group
By Franz Grainer

Illustrations to Chapter IX. On the arrangement of groups

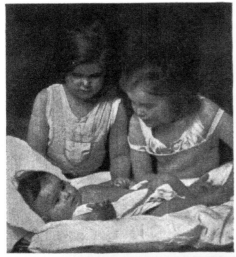

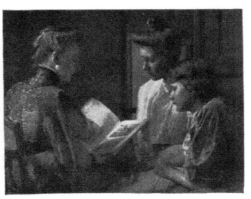

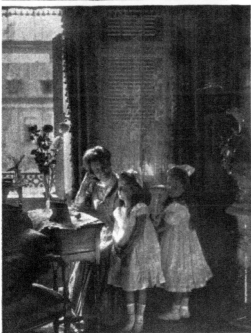

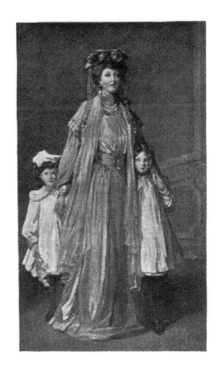

Portrait Group
By R. DÜHRKOOP

Portrait Group
By WILHELM KUBELER

Portrait Group
By FRANZ GRAINER

Painting
By JOHN LAVERY

Illustrations to Chapter IX. On the arrangement of groups

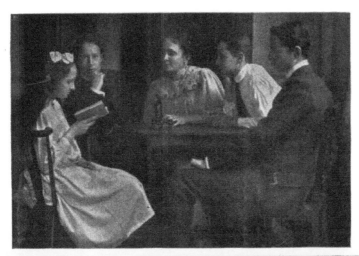

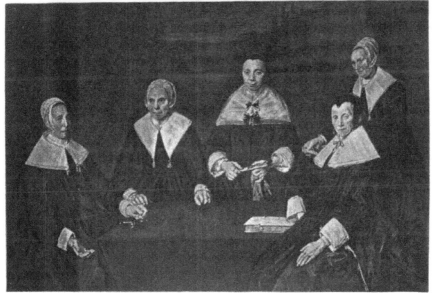

Portrait Group
By WILHELM KUBELER

"Superintendents, Old Woman's Home"
By FRANZ HALS

Illustrations to Chapter IX. On the arrangement of groups

O take a satisfactory group is one of the most difficult tasks of portrait photography, largely because it represents the combined forethought and discrimination of as many efforts as there are sitters in the portrait. For *a group is nothing but a combination of two, three, or more single portraits.*

For that reason there is little to say about the detail arrangement of such portraits. The same rules that apply to the full front, profile, and three-quarter views should also guide the operator in the management of the various figures of a group.

The main difficulty lies principally, if not entirely, in bringing the conflicting elements together, to pose the figures in such a way as to form an harmonious whole. There must be some sort of connecting link. This is generally produced by some object in which the interest of the sitters is supposed to be concentrated. Accessories play an important part in the photography of groups.

In groups of more than three or four persons special attention must be paid to the "headline" (produced by drawing a line from the top of one head to the others throughout the whole group). There must be a certain swing to the line, as shown in the accompanying

diagram. If the headline is awkward the whole portrait is awkward. In the famous Franz Hals picture you see a modification of the second line, and in the Kubeler group of girls a variation of the fourth.

Portraits of this sort are rarely attempted in ordinary studio photography. And for art's sake it is well that it is so, as they demand more knowledge, care, and time than most photographers would be able to

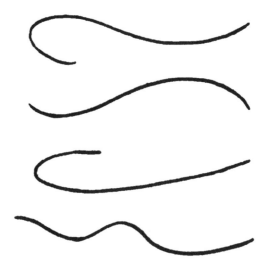

give to them. The average pictures of outing and picnic groups only prove this too clearly. They are always stiff and absurd looking. The picture of the National Convention members at Boston was a memorable exception. The sitters, however, were all photographers, and that counts for a lot. They were accommodating, at least.

For portraits of two or three people there exists one rule which should never be broken. The heads

should never be placed at the same height, unless they are symmetrically arranged, as on a book cover, for instance. It can be done in portrait photography only when the composition is exceedingly clever, as in Fig. 4, but the opportunities are rare. In all other portraits, even in Figs, 1 and 2, you will notice a slight variation of height.

As for the combination of the different views of the head in group, almost everything is permissible. In Fig. 1 you have a combination of the profile and three-quarter view. This is about the most favorable arrangement for a bust portrait of husband and wife. The full front view arrangement is either silly or too sentimental. It is only suitable for children, as shown in Fig. 3, one of the best portraits Mrs. Kasebier has made. In the combination of the profile and full front view some object of interest is necessary. People do not sit at right angles and stare into space. If the head of the woman were turned, of course, it would be different, but then it would become a variation of the theme in Fig. 1. Both heads in profile, as we see on medals, is too severe in effect to be specially recommended. It will serve only special purposes.

In groups of three people the possibilities of composition become exceedingly varied. It is, perhaps, best to follow some geometrical shape, as the triangle in Fig. 8, or the circle in Fig. 5. In Fig. 6 you will notice a concave and in Fig. 7 a convex curve. Should you be bent on further investigation, you will find out that the triangular form is really at the bottom of all

these arrangements. The heads in all these four pictures form some kind of a triangle. In groups of four they often form some four-sided shape. And it is quite natural that it should be so. In a three-figure group there are three points of interest represented by the heads, and in a four-figure group, four. In composition one can never get away from the fundamental geometrical forms. A photographer should know this, but never lay as much stress upon it as some writers of composition have done. Cleverly composed groups repeat these laws, even against the will of the photographer; they come naturally. It is well, however, to know these things and to reflect upon them occasionally.

The children group, by Dührkoop, Fig. 5, is charming. Groups are specially suitable for children. Children are more diversified in their movements than grown people, and lend themselves more easily to a pictorial composition. It is difficult to make two or three grown people look as if they were occupied in a half way sensible manner. Every operator of experience will agree on that point.

Fig. 6 is, in a way, a masterpiece of home portraiture. The figures are well posed and the handling of accessories (there are almost too many) is perfect. The more unconventional the poses are in group the more natural an impression they are apt to give.

Fig. 7 is a trifle stiff, but it is noteworthy for the successful management of three profiles. In three-figure groups, an object of interest, as in this picture,

is almost indispensable. Grainer avoided it by the introduction of an exceedingly clever light arrangement. The only other way is to make them decorative in tendency, as shown in the Lavery portrait, Fig. 8. The figure is rather profusely garbed, but draperies always help a portrait. A lady in a tailor-made dress would not look well in this pose. The figure is slightly bent forward, as if walking. Also, this helps the composition. One cannot simply place full-length figures beside each other and hope to make a successful portrait. The painting by Zorn of himself and his wife (in my chapter on standing positions) is one which only proves the rule. In groups the people must do something or be interested in something, or the result will in nine out of ten cases prove unsatisfactory.

Fig. 9 is one of the most successful five-figure groups I have ever seen. This Darmstadt photographer seems to have a rare faculty for taking groups. He has made a specialty of it. Of course, I could point out a few minor shortcomings—the headline is a trifle too straight and the figure of the young man at the right a trifle too large—but it is in every other respect just what a photographic portrait group should be—a simple composition, without any groping for an elaborate "artistic" effect. Whether the likenesses are good, of course I cannot say, but they convey the impression of being natural and in no way strained. As soon as a person is occupied, no matter in what way, the facial expression changes, and a *straight* likeness, as in a bust portrait, becomes impossible. All you can hope to get

99

is a more intimate and individual, but less typical, expression.

In the portrait of the Superintendents of the Old Woman's Home there is no object of interest. Four of the women stare straight into your face. Franz Hals simply painted five portraits and patched them together. And I do not know whether that is not the wisest way. As I have said at the start, a group portrait is nothing but a clever combination of several single portraits. And the combination in this instance is accomplished solely by the headline. Every figure (four of them at least) would furnish a portrait satisfactory in itself; they become an harmonious entity solely by space arrangement, *i. e.*, the way in which they are placed and related to each other.

CHAPTER X

ON TONE AND VALUES.

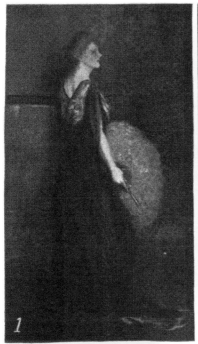

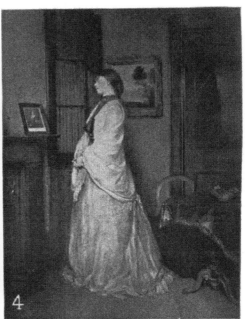

"Portrait of Madame B."

By Julius Stewart

"Mr. A. J. Cassatt"

By Wilton Lockwood

"The Engraving"

By Ambrose McEvoy

"Fantasy" (Photograph)

By P. G. Terras

Illustrations to Chapter X. On tone and values

"Flower Girl"
By SIR JOHN MILLAIS

Portrait
By W. WEIMER

"Max Klinger"
By N. PERSCHEID

"Baron Lambermont"
By EMILE WAUTERS

Illustrations to Chapter X. On tone and values

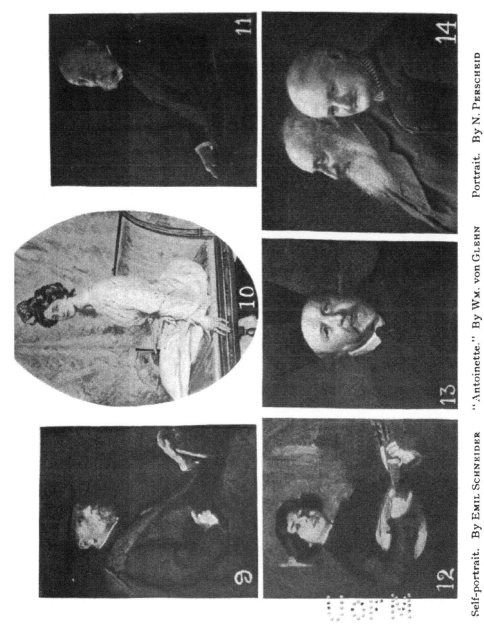

Self-portrait. By EMIL SCHNEIDER " Antoinette." By WM. VON GLEHN Portrait. By N. PERSCHEID

E live in a tonal era. Every photographer aspires to it more or less. In Sarony's time detail was the ambition and ideal of the professional photographer. To-day it is the harmonious appearance of a print.

What is tone? Opinions, I fear, will largely differ. Trying to convey it in a few words, I would say: a pictorial representation in which all light and dark planes, all middle tints and gradations, from the darkest spot to the lightest light, are arranged in such a manner that they form an harmonious tint, in which nothing is obtrusive or offensive to the eye. A picture is "in tone" as soon as it accomplishes this. Also, the painter will agree on this point, with the difference that he applies color notes instead of monochrome tints.

In order to realize a perfect tonality the values have to be correct. *Values* is an oft misquoted word. It means nothing more nor less than the relations of the tonal gradations (of the various objects represented to each other).

Look, for instance, at the painting entitled "The Engraving," by Ambrose McEvoy (Fig. 4). In this picture the table-cover, the shimmer of the picture frame, the lady's dress, the color of her hair, the carpet,

and wall paper, all had to be considered and arranged in such a manner that nothing would stand out too boldly. The painter was successful in subduing all minor interests to the principal figure without losing too much of the detail. This is what the writer of these lines considers a good example of tonal arrangement.

Tonal composition consists largely of a right sense of proportion, to understand the beauty of different degrees of tonality, the relation of tone in regard to size and shape against each other, and to bring all these possibilities into full play in each new effect. And this is largely a matter of feeling, as the problem is a new one with every sitter. Just as the texture and complexion of the skin and hair, and the construction and expression of the face and head and neck, not to mention the color of the eyes and lips and the clothes, are different in every sitter, so the problem is a different one with every new exposure.

Few photographers nowadays apply as many distinct tonal variations as are in this picture. Formerly it was the fashion. When Davis and Sanford were at their prime, their gray platinum prints showed from sixteen to eighteen middle tints. They avoided black entirely. The result was that their prints gave the impression of a soft, refined gray, with any amount of subtle variations in the detail.

Our present convention pictures show that most men are satisfied with a simpler differentiation of values. It will be difficult to pick out in most pictures

more than six or seven distinct tonal planes. The extreme tonalists, like the Secessionists, even go so far as reducing them to two or three tints. In many of Coburn's portraits you can trace only an exceedingly light tint and two middle tints. And in many of Kasebier's and Steichen's, and some of our advanced professionals, when they try to do the "artistic trick," you will find two or three flat tints in the face against an opaque background. They have fallen into the common error of mistaking darkness and monotone effects for tonality.

Tonality is possible in any shade from black to white. Fig. 10 is as good an attempt at tonality as Fig. 11. It is, however, difficult to convince people of this fact. The present trend, however, is for dark-toned pictures, and as the same laws apply to all tonal compositions, I have chosen pictures of a dark tonality for my analysis.

Figs. 1 and 3 are both photographically possible. They are both what I would call five-tone arrangements. Maybe some will count six tones, but there is no use of splitting hairs. In the portrait of Mme. B. you have the fine contrast of the dark dress and the flesh tints. This makes two. Then there is the gray tint of the hair, which is repeated in the fan. You will notice that this same tint also produces the shadows on the arm and neck, the embroidery of the dress, and some parts of the background. Besides, there is a fairly dark tint which makes up the largest part of the background and the highlights on the flesh tints. This

makes five tones, and they are very judiciously used, as they produce a decided contrast. In Fig. 3 you will find the same, only the tones are nearer related to each other and used with less variety in the juxta-position. The result is that the portrait of Mr. Cassatt is more monotone than the other.

In Fig. 2, a photograph, we have four-tone arrange-ments. A flat middle tint all over the neck and face, with a vague shimmer of highlight, a dark bust, and a monotone background.

In Fig. 6 we have a picture that is "out of values." It may be different in the painting itself, but there is no doubt that the effect is restless and confusing in the reproduction. The eye wanders about and is fastened on no point in particular. This is one sure sign whenever the values are incorrect. Another is, if the eye goes at once to one point which should not be the principal attraction. In the portrait of the boy (Fig. 8) the collar is too prominent and the flesh tints of the boy's face a trifle too dark. The tonality suffers thereby. In the portrait of Max Klinger (Fig. 7) it is not so much the collar as the ear. In Fig. 5 neither the hands, the books, nor the back of the chair are in tone. A painter may possibly render this diversity of objects interesting in color, but it would be difficult for a photographer.

Simplicity and omission of unnecessary accessories will be the best helpmates toward accomplishing tonal-ity in ordinary photographic portraits, such as most people demand. Lack of tonal gradations seems to

me just as unwise as the multitude of shades and tints of former years. Figs. 11 and 14 represent excellent tonal arrangements, but they are, after all, a trifle dull for portraits. In Figs. 9, 12, and 13 there is more contrast, more juxtaposition of light and dark, and, for that very reason, more life, more vitality. The picture grows in interest.

I cannot repeat often enough that it is, after all, the face which we want most in a portrait. In the flat-tone treatment all the beautiful modelling is lost. In the Rubens' portrait (Fig. 13) we have modelling first of all, the tonal variation is largely in the face, the subtle tints melt almost imperceptibly into each other, and yet show the construction, the texture of the face, and the character of the man. And yet the picture is perfect in tone.

CHAPTER XI

ON LIGHT EFFECTS

"Rubens"

By Van Dyck

"Photo"

By H. Kühn

"Mrs. Jas. Campbell" (fragment)

By Raeburn

"The Violinist" (fragment)

By Wilton Lockwood

Illustrations to Chapter XI. On light effects

Photo
By C. Ruf

Photo
By C. Ruf

Photo
By Bruno Wiehr

Photo
By Dührkoop

Illustrations to Chapter XI. On light effects

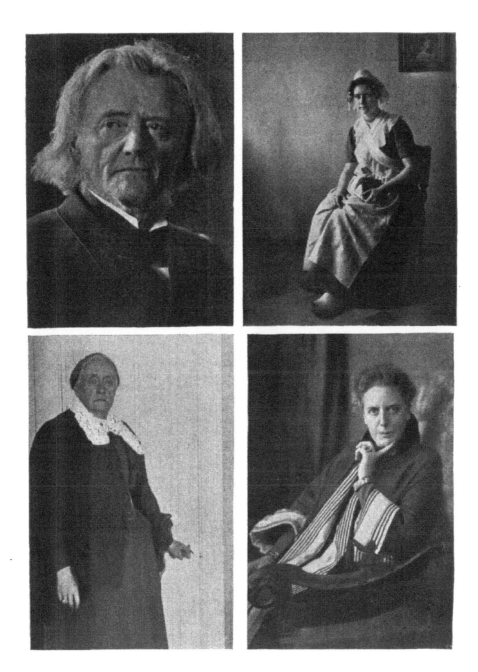

Photo
By Dührkoop

Photo
By Franz Grainer

Photo
By Reginald Craigie

Photo
By Erwin Raupp

Illustrations to Chapter XI. On light effects

N photographic portraiture the simple light effects are the best. It is a different matter if you are engaged at a figure composition; then you may indulge freely in all kinds of light experiments.

But in a photographic portrait the light effect should be soft and pleasing and in no way obtrusive. I suppose every photographer has his own system of lighting and his own ideas about the exact angle of the skylight, about the relative positions of the sitter and the camera, and the management of screens and other studio fixtures. And the more practical and precise his system has become in the run of years, the simpler it will be. For a system of lighting is nothing but the simplification of light conditions for practical purposes. I, therefore, do not intend to talk about frontal, side, and marginal lighting, nor about Rembrandt, Shadow, and Line Lighting, or any other method of lighting, being of the opinion that the photographers know these things much better than I. All I wish to show is the guiding principle that somehow should control all efforts and results.

It is my contention that the most natural light effect would be also the most effective one for portraiture. An English photographer (I have forgotten his name)

is responsible for the accompanying diagram; he claims that they present the simplest arrangement of pictures with the most natural result. I cut them out of some foreign magazine eight or ten years ago. Study them, and you will see that they still tell their lesson today.

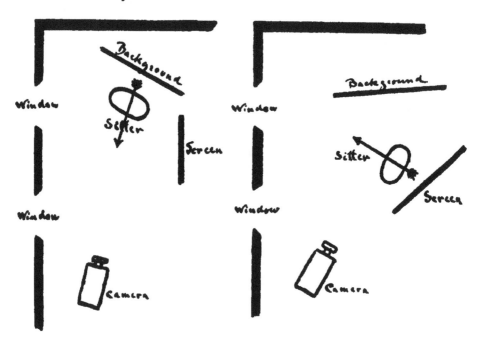

If it be possible to come down to one kind of light and to pronounce it as the most serviceable and natural one, it is that of the diagrams. It shows the face as the majority of Old Masters have shown it, with the strongest highlights on the forehead and nose, and a few less vigorous on the cheek bones, upper eyelids, around the mouth and chin. The light effect of Van Dyck's "Rubens" (Fig. 1) is typical for old-time por-

traiture, and cannot be surpassed for clearness, for forceful simplicity, and effective modelling. Its laws have been closely followed by all good portrait painters. The face should present the largest lighted plane in a portrait. Only then preciseness of pictures and plastic results, after all the most desirable qualities in a likeness, will become possible.

The modern tonalist has overstepped this convention. Weary of the everlasting repetition, he has introduced all sorts of innovations. He is fond of working in middle tints without strong contrasts. Look, for instance, at Craigie's portrait of an old lady (Fig. 10). Do you really consider that method of flattening and subtle gradations superior to that applied in Fig. 12? Of course, it is largely a matter of taste. I am convinced, however, that a likeness is easier to obtain in the straightforward lighting of Fig. 12 than the blurred effect of Fig. 10 or 4.

Figs. 2 and 3 are treated in the Van Dyck manner. They show the difference between a photographic and a painted portrait. It seems to be impossible in a photograph to get the shadows as precise and at the same time as translucent as in the Raeburn portrait. The photographer is obliged to work in broken tints and subtler monochrome gradations.

There has been a tendency among modern painters to reduce the proportion of lighted planes to their minimum. The ratio of space devoted to lighted planes has steadily grown smaller. The Italian masters give to the lighted sections about $\frac{1}{5}$ of their canvases,

Rembrandt reduced it to $\frac{1}{6}$, the English portraitists allowed still less, and Whistler in some of his portraits, for instance, his "Sarassate," used only $\frac{1}{18}$ of the canvases for his light arrangements. "The Violinist," by Wilton Lockwood (Fig. 4), is a good example of this style. This elimination of light is sure to produce a tonal effect. The darker masses concentrate the eyes upon the lighter part of the picture, and the more delicately the light arrangement will lead the eyes from one point of interest to the other one, the more harmonious and beautiful will be the pictorial effect. But this style does not permit strong contrasts; the face cannot be portrayed with normal clearness. You will notice that the collar and the rim of the violin carry the strongest highlights. The face is really entitled to them. The larger the range of light and shade the more accurate in expression, in construction, and modelling the face will become. The strongest highlights on accessories always sacrifice something of the likeness to a pictorial effect.

The photographers to a large extent have followed in the footsteps of the painters. The Secessionists and extremists in this respect are strictly imitative. The source of light applied in photographic portraiture has become smaller and smaller in recent years. And the result is the same as in painting. Portrait photography has become more pictorial, but less clear and precise in expression.

In Figs. 5, 6, 7, and 8 we will notice a number of curious, out-of-the-ordinary light effects. They are

interesting and show clever manipulation, but they will never do for portraiture. To concentrate the light merely on the forehead (Fig. 5), on the upper part of the face (Fig. 7), on one cheek (Fig. 6), or on a part of the face (Fig. 8) is in no way conducive to the producing of a likeness. People will wonder why the light strikes the face in such a peculiar fashion. They will find it odd and eccentric, but I fail to see that anything is gained thereby either for the photographer or the sitter. The source of light should explain itself, or rather strike the face so naturally that no explanation is necessary. If in Fig. 8 the peculiar light effect were produced by a broad-brimmed hat, there would be no objection, but as it is, the effect is meaningless. Nor is it particularly beautiful, which would be an excuse.

Fig. 9 is an excellent tonal composition. The face is kept entirely in middle tints. But everything essential has been preserved. There is characteristic expression, good modelling, and even preciseness in the shadows without the usual opaqueness.

Fig. 12 is a good example of a portrait in a lighter key. A stronger accentuation of highlights would not have harmed the picture, but even as it is, it is clear and light and expressive, as a portrait should be. The keynote of color in the human face is light, and it should be rendered in that way. The majority of portraits today look as if the people depicted were mulattoes or quadroons, which is not particularly flattering to the sitters. Fig. 9 also shows the value of lighted planes for the expression of color. The

feeling of color in monochromes is expressed by contrast, and contrast is possible only by the juxtaposition of a variety of tints ranging from white to black, as seen in Figs. 1, 2, 3, 11, and 12.

My series of discussions on "Composition in Portraiture" have come to an end with this chapter. My readers, at least those who have remained loyal to me, have no doubt realized the object of these articles. I have tried to convey those principles that everybody engaged in the profession should know. With a little leisure to investigate and analyze, everybody will arrive at the same conclusions. They will furnish a reliable basis to work upon. The remainder necessarily must be left to years of experience and experiment. Only in that fashion will my readers arrive at the mastery of composition, not merely of its fundamental principles, but all its intricate subtleties and marvellous possibilities.

DALLMEYER'S
PATENT PORTRAIT LENSES

**For forty years their supremacy for studio-portraiture
has remained unchallenged**

In the world's best studios to-day there are more Dallmeyer lenses in use than all other makes combined. The Dallmeyer Portrait Lenses still possess that indefinable "something" which places them ahead of every other kind. The best photographers know this as well as do the makers.

DALLMEYER'S
STIGMATIC LENSES

Series 11. Convertible. Speed F-6

FOUR LENSES IN ONE

Three Regular Lenses, each of different focal length, and a Wide Angle Lens, suitable for instantaneous work, Landscapes, Groups, Large Heads, Photo-engraving, etc.

They are about $33\frac{1}{3}$ per cent. lower in price than other lenses of similar character.

ASK YOUR DEALER. SEND FOR DESCRIPTIVE CATALOGUE

BURKE & JAMES
118-132 West Jackson Boulevard, CHICAGO

THIS VOLUME is for reference and to assist the up-to-date photographer; but the most essential adjunct to the photographer—in fact, it is as important as his lens —is a simple, practical Flash Lamp, one that occupies but little space, is easily operated, and requires but the safest and most easily obtained of all agencies—alcohol. No priming of ether or guncotton, no troublesome and unreliable dry batteries, no slow-burning fuses (electric flash lamps are operated by a fuse, and a desired expression is often lost by waiting for fuse to reach fusing point after electricity has been switched on), or complicated wires to bother with.

¶ The Nichols Flash Powder is safe to handle, wonderfully actinic, and will not ignite by friction. For best results with Nichols' Flash Lamp always use Nichols' Flash Powder.

¶ Numberless photographers have more than paid for a Nichols outfit with their first negative.

——————— MANUFACTURED BY ——————

CHAS. H. NICHOLS COMPANY, ST. LOUIS, MO.

Lightning Source UK Ltd.
Milton Keynes UK
UKHW030642111021
392013UK00005B/242